BURFORD
THROUGH TIME
Raymond Moody

AMBERLEY PUBLISHING

First published 2010

Amberley Publishing
Cirencester Road, Chalford,
Stroud, Gloucestershire, GL6 8PE

www.amberley-books.com

Copyright © Raymond Moody, 2010

The right of Raymond Moody to be identified
as the Authors of this work has been asserted
in accordance with the Copyrights, Designs and
Patents Act 1988.

ISBN 978-1-84868-659-5

British Library Cataloguing in Publication Data.

A catalogue record for this book is available from
the British Library.

Typeset in 9.5pt on 12pt Celeste.
Typesetting by Amberley Publishing.
Printed in the UK.

Introduction

Burford has been here since at least the seventh century. Photography did not arrive here until after 1850 though we have a few drawings that will take us back another forty years. If you wish to picture the defended river crossing between Wessex and Mercia that Burford was once, or the village of the Domesday Book, the thriving market town of the Middle Ages or the coaching and racing resort of the eighteenth century you must use your creative imagination, though plenty remains here to feed your fancy. In the reign of Victoria while industrial prosperity spread across the land, the railways brought modernity and much of England was radically changing Burford remained depressed and largely unaltered. It would not be quite true to say that Burford entered the twentieth century as it left the eighteenth, but until the motor car brought the world here again, the poverty of the town spared Burford much red brick and a surround of villas. If a Burford dweller of three or more centuries ago were to rise from the churchyard and, rubbing the mould from his eyes, were to stroll through the town, except at the top of the hill where the roundabout has destroyed the ancient settlement of Bury Barns, he would know at once where he was. He would note alterations in detail, occasional losses, some small additions and the urbanisation of the streets but he would not be lost. Outside the town it would be another matter. The enclosures of 1773 and 1795 transformed the landscape that he knew, creating the fields of today and re-aligning the roads.

In the twentieth century Burford's historic character was recognised: most of the town is a Conservation Area in an Area of Outstanding Natural Beauty. Almost all the properties in the principal streets are "listed". In spite of great pressure for development no serious extension of the outline of the town has been allowed, and construction has been restricted to infilling or conversion of barns and garages. Such new building as there has been is perforce in traditional style. Without

this control Burford might well now be a town of over ten thousand inhabitants, not the bare eleven hundred of today. The ancient streets of the town have hardly changed. What has changed is the way we live in them. In the eighteenth century they may have been busy with coaches and carts day and night, but nineteenth century photographs of the High Street show few persons and even less activity. Traffic east to west was largely taken out of the town when around 1812 the turnpike road passed by at the top of the hill, and travellers walked down the hill with their luggage following on a handcart. This was done to spare horses the gradients, but there was as today no relief for the north to south traffic. For seventy years a bypass has been talked of but has never come, and now the relief of the town is balanced against the preservation of the quiet meadows over the bridge. Burford's High Street is as active and crowded as ever with traffic on the road and visitors on the pavements. To avoid vehicles in photographs today is impossible and parked cars are as much a feature of the roads as the lines and the signs. The town has always been used by far more people than live here, and much of the money spent in Burford now has been earned somewhere else. Once it was possible to satisfy all the essential demands of a household here. Now, though Burford still has a good range of basic shops, it is desire and not necessity that drives trade as visitors come here for the character of the town and its shops. By day it is bustling with the life of the twenty-first century, but in the quiet evenings or when the mist rises from the river the past inhabits the present and the imagination can people the buildings with those who once lived in them. This then is Burford as pictured in the past two centuries and as it is now presented for your view.

I am very grateful to Burford's Tolsey Museum for allowing me to use so many images from its fine collection, and especially to Peter Gould whose superlative photographic skill and generosity with his time has prepared so many of them for this book.

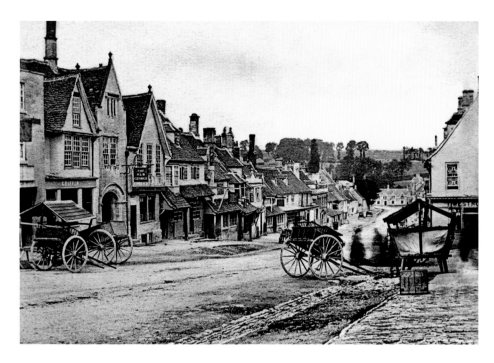

The Changing Life of Burford: Looking North

This picture and that overleaf capture perfectly the air of Burford in the mid-nineteenth century. The function of the matching stalls on either side of the street remains unknown. Two phantom figures on the right moved away during the exposure. The George Inn ceased trading in 1800 but its sign remained.

Below, prosperity has brought traffic.

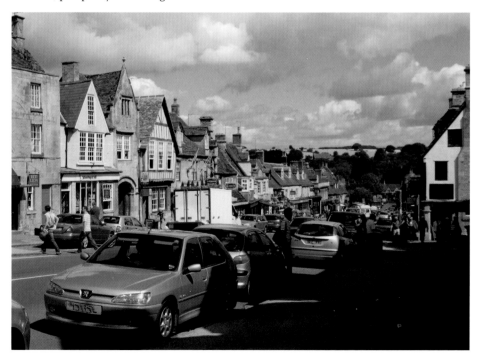

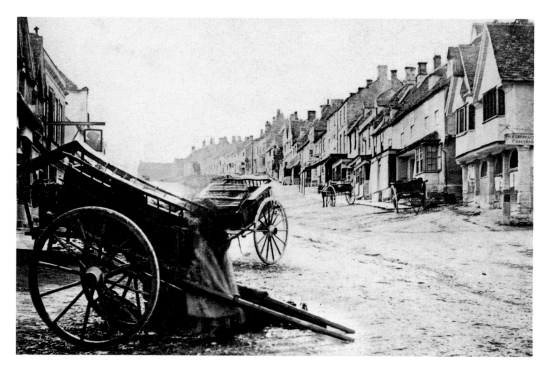

The Changing life of Burford: Looking South
The seventeenth-century clock on the Tolsey and the bell housing were replaced around 1865. Not long after that Newman the draper rebuilt the frontage of the house above the Tolsey and the trees were planted on the hill about 1874. The sign of the Wheatsheaf can be seen on the left, above the cart with another phantom figure.

Below, the same view today.

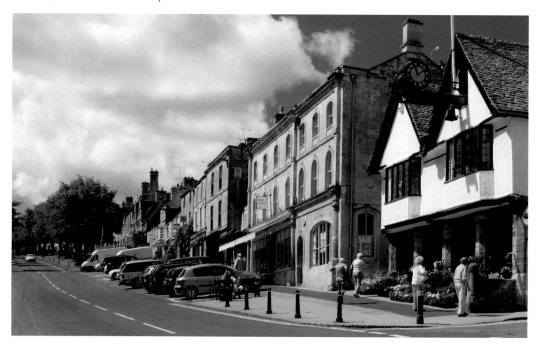

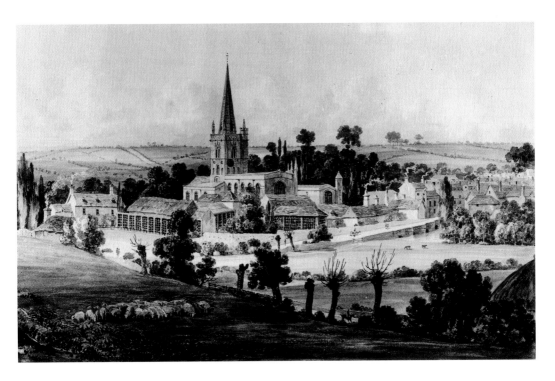

The View from Westhall Hill

This 1815 painting by George Shepherd was later engraved for the Antiquarian's Itinerary. At the time the twin houses by the bridge were not yet built and Ladyham is clearly visible to the left of the picture. The buildings between Ladyham and the road are Ansell's tannery. The modern photograph shows later buildings above Witney Street but even in winter the trees now hide Ladyham.

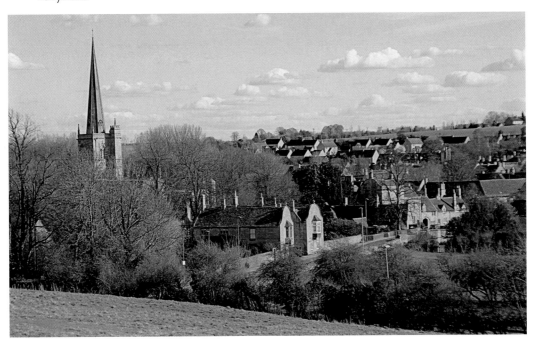

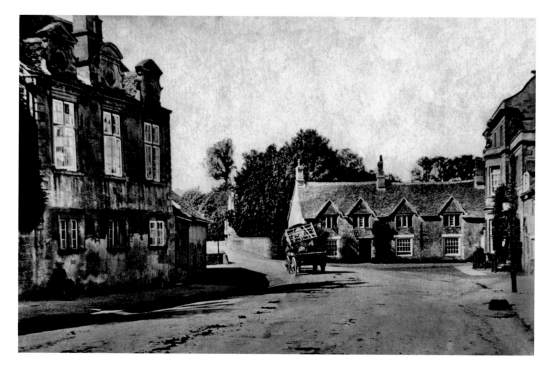

Only the Traffic Changes

In 1900 or earlier the great lime tree by the bridge was absent or hardly grown. The deep drainage gulleys on either side of the carriageway crossed by stone slab bridges lasted until 1978. Horse droppings are one constant feature of all roads in the past, traffic travelling in the middle of the road. The sketcher on the pavement might be there in any year.

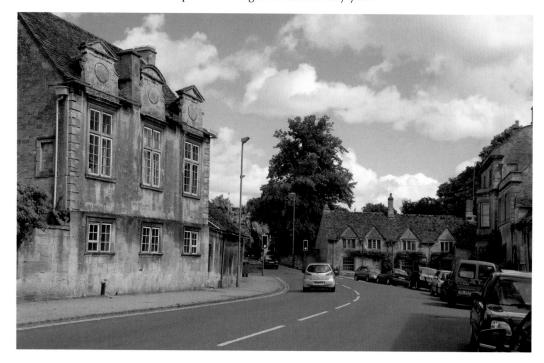

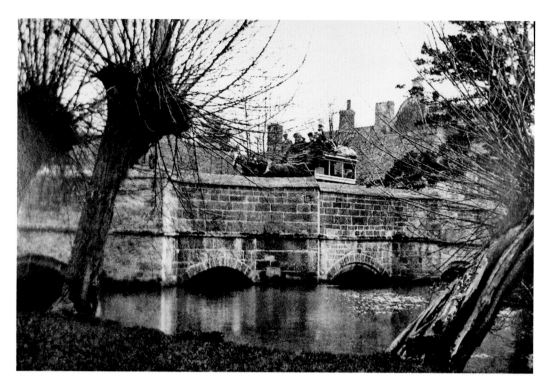

Over the Windrush

In 1322 a special tax was granted for the repair of this bridge, and little has changed since except the traffic. Here Mr Paintin's two horse omnibus is setting out to go over the downs to the railway station properly called "Shipton for Burford". Now lights control the heavy traffic.

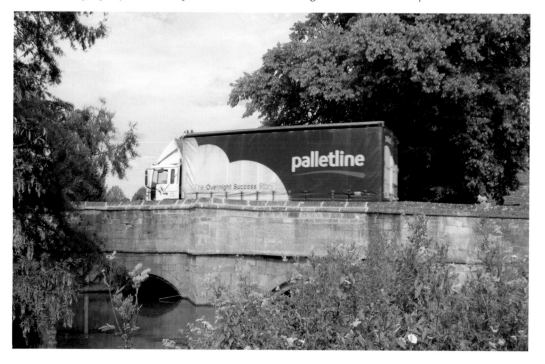

Vanished House

The building with its arch is the old King's Head Inn, half of which disappeared when the extension of the building to its left was erected at some time before 1815. In the angle is the entry to Ansell's tannery and next to it one of Burford's departed buildings. The facing range was improved by Simon Wisdom in 1571 when he gave it as part of the endowment of Burford's Grammar School.

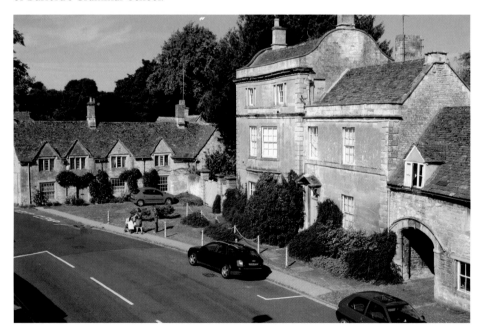

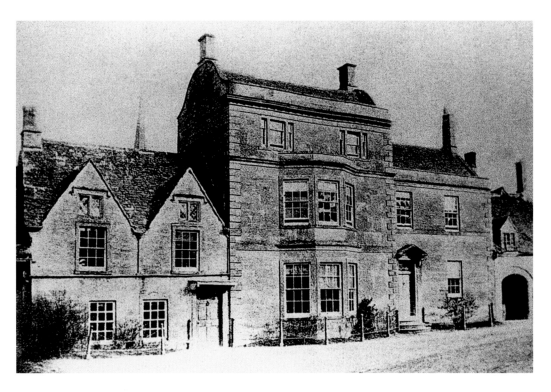

A House too Many

A clearer view of the building demolished in 1868 to make the entry to the grounds of Riverside House. It is difficult to make sense of the internal arrangements of this house with the upper windows placed as they are. The road to the bridge was raised in the late seventeenth century.

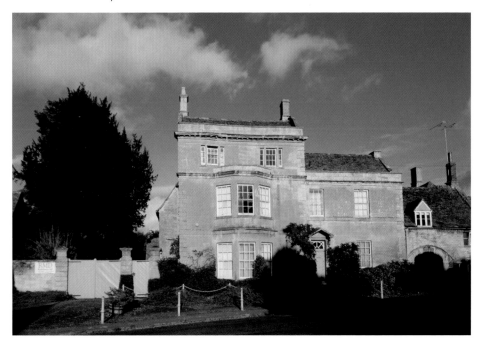

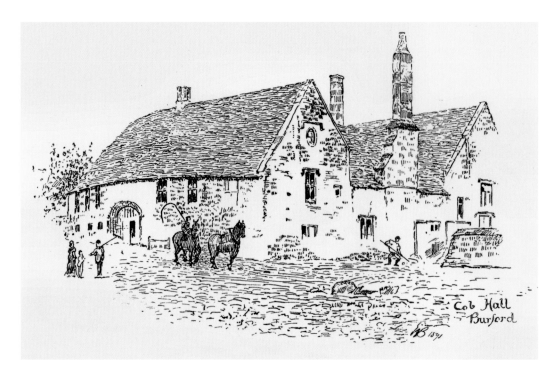

Another Lost House

Of Cobb Hall only the archway and two ground floor rooms survive, and this drawing published by Monk in 1891. The large Tudor courtyard building was left to the town in 1590. It was successively an inn and an important house, but before its demolition in 1876, fallen on hard times, it housed three dwellings, a joiner's shop and a boys' school.

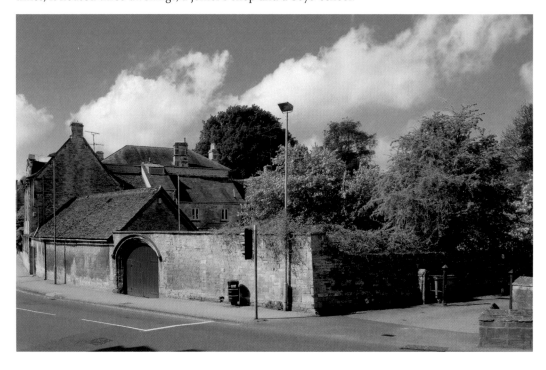

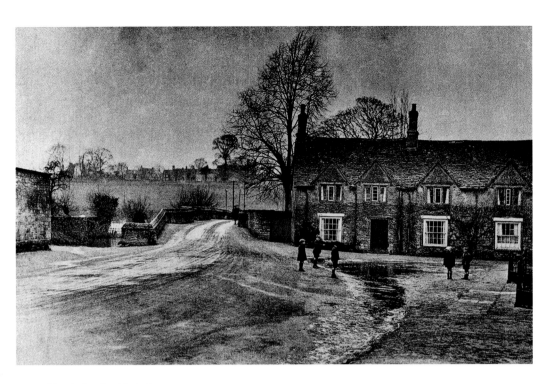

Floods in the High Street

Children were more visible on the quiet streets than adults. This winter scene when the lime tree was smaller shows the cobbled triangle flooded with rain water as it often was until the drainage works of 1978.

Below is the same view in the flood of July 2007 when the river rose rapidly overnight and low lying houses were inundated.

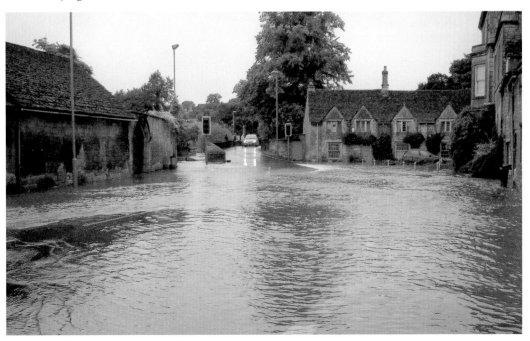

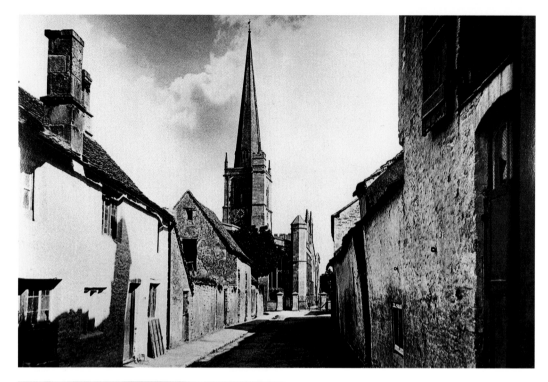

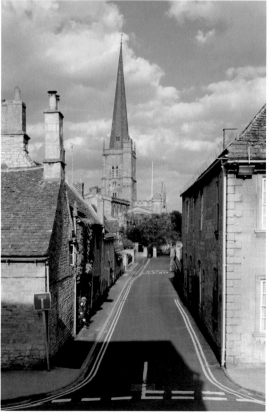

Lawrence Lane in the early Twentieth Century
On the right, Mr Potter's corn stores. At the end on the left is the barn which, threatened with a corrugated iron roof, was replaced with a neat stone cottage by the local architect Russell Cox.

Below, Lawrence Lane today. Where Mr Potter's storage and the weaving sheds stood beyond, in the 1930s a hall with stage and balcony was built used then by both school and town as intended. Now it has been taken as part of the school's accommodation for boarders.

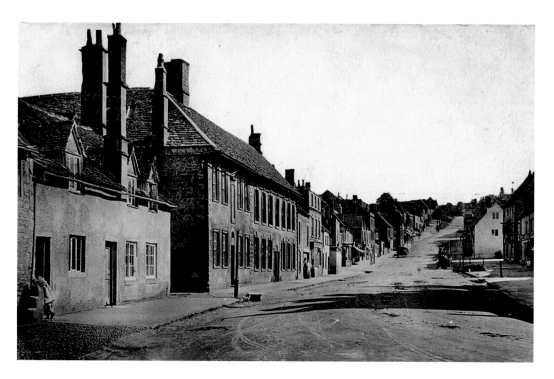

Cottages and a Former Inn

On the extreme left is the mounting block of the old King's Head Inn, necessary for the less agile when horses were the only transport, and next to that two cottages. All the property between Lawrence Lane and the river was acquired by the Cheatle family, four generations of doctors who lived in Riverside House.

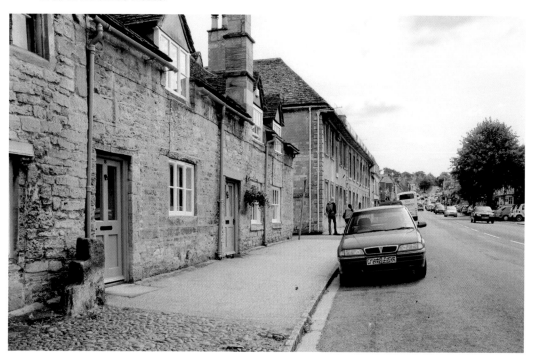

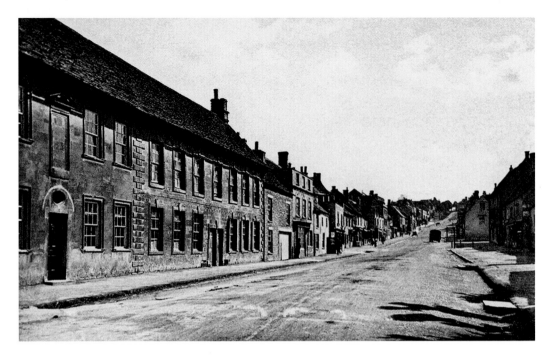

Changing Use

This on the left was the King's Arms Inn in the eighteenth century. The corner building with its single door became the house of Mr Potter, corn merchant, and two or more houses served by the two doors were beyond. The Grammar School acquired these in 1924 and Mr Potter's house in 1936. Now all is Burford School's boarding accommodation for girls. The next building with the wide entry, now partly filled, housed the offices of Burford's own Gas and Water Companies.

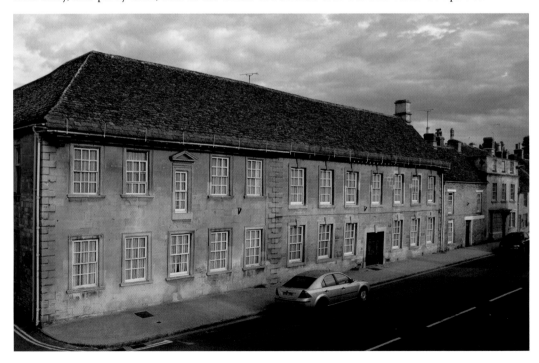

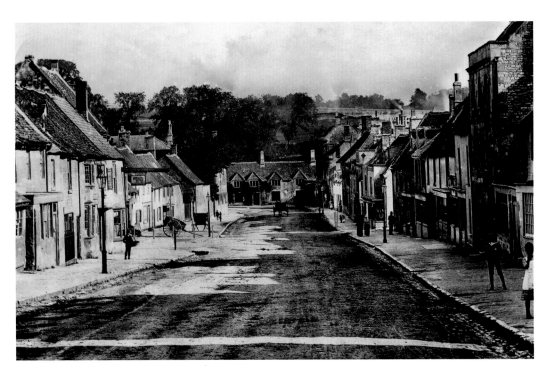

Burford in Decline

A mood photograph of the lower High Street in the later nineteenth century, perhaps at the lowest point of its disrepair. Notice the street lights: the original contract of the 1860s was for seventeen standard gas lights, not to be lit on nights either side of a full moon.

Below, the floodlit street of today.

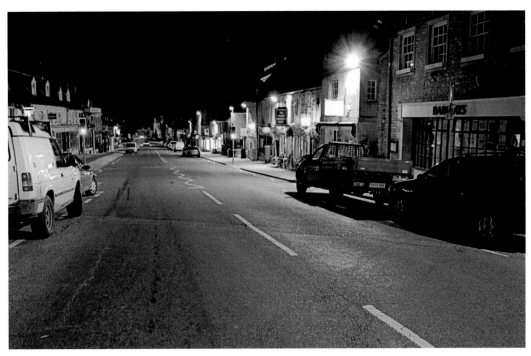

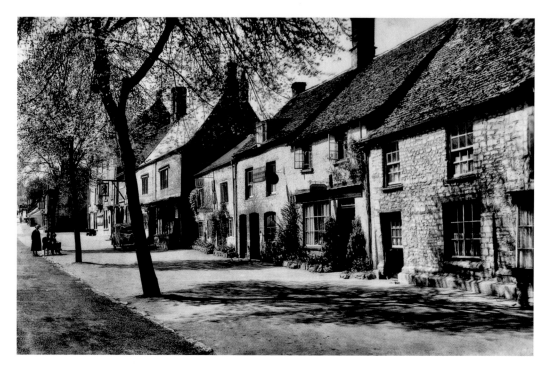

The West Side of the Lower High Street between the Wars
Mrs Nash in what is now No. 22 offers teas and accommodation for the Cyclists Touring Club.
No. 24 was still the Lower Forge recorded from the Middle Ages and Halls, blacksmiths and
farriers, were still working there. Now wisteria clothes the houses and a solid line of parking
usually restricts the view.

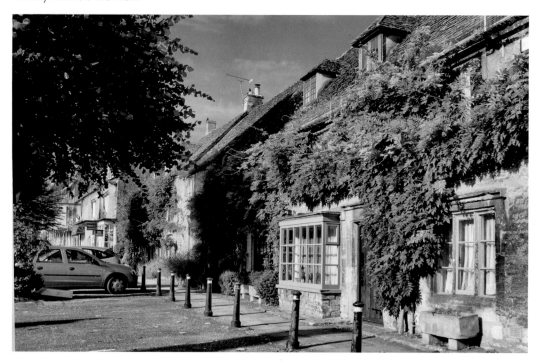

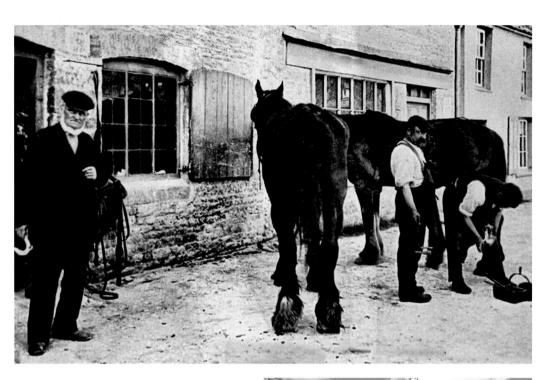

The Lower Forge at Work

The Hall family, blacksmiths and farriers, at work. They also kept the Bear Inn nearby until it closed to become Bear Court while Billy Hall, the last member of the family, continued living here until the 1980s.

Below is the house today, with roses, wisteria and lavender.

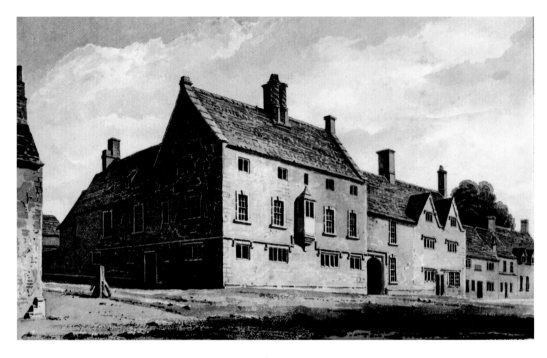

The Falkland Hall

J. C. Buckler, Oxford architect, made this drawing in 1821 when the cottages behind in Priory Lane were part of the building. It shows how much architectural detail Burford lost in the nineteenth century. Buckler knew it as "Old House of the Silvesters" built by the cloth merchant Edmund Silvester in 1558, and during the Commonwealth the Bear Inn was built next to it. Notice the public pump in the roadway.

Below, as it is today.

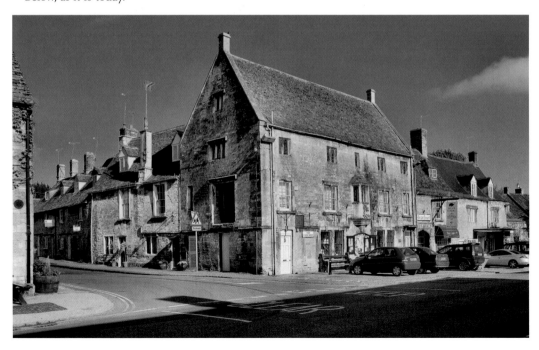

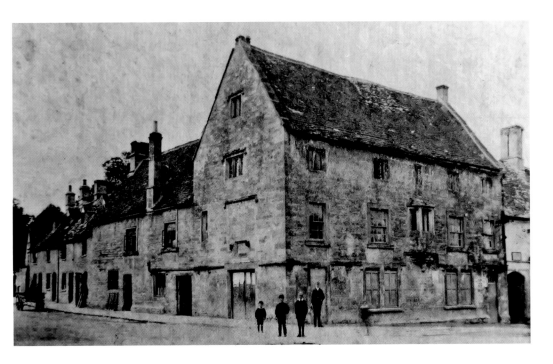

The Falkland Hall

The building became part of the Bear Inn but was divided into tenements later. In 1888, the central chimney gone, it became a Salvation Army hall. In 1904 it was bought by the Burford Recreation Society, and then in 1920 by the War Memorial fund. A first floor entrance with removable steps was built for the gallery of the hall. Miss Gough's Chip Shop with its sign was behind.

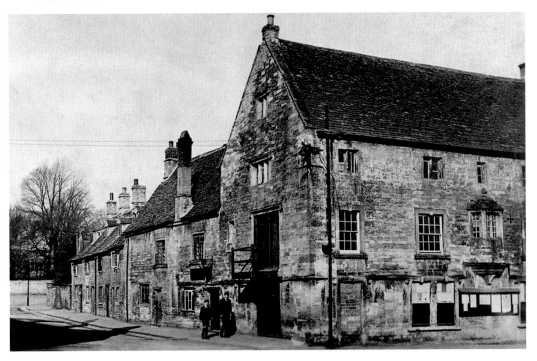

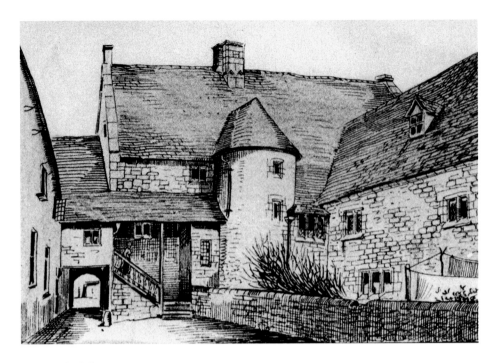

The Yard of the Bear

This drawing of unknown provenance shows the yard of the old Bear Inn which included the building later called the Falkland Hall. Like the central chimney, the spiral stair turret was removed in 1888 when the building was converted to a hall and the stone was used in the building of Tiverton Villa in the Guildenford.

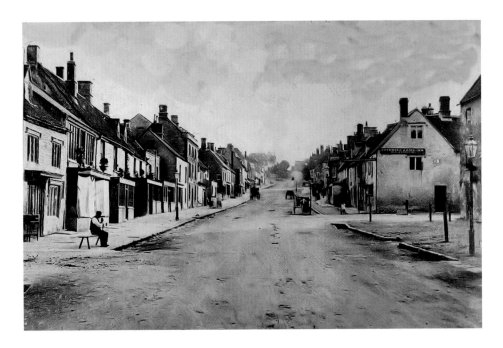

Around 1900

On the extreme left is the building with a canopy on its front which became the property of the school's Foundation Governors between the wars. Next to it, behind the seated figure, is a building, later demolished, with high windows that suggest a connection with the weaving trade. In the gap that was left the District Council has built a public convenience.

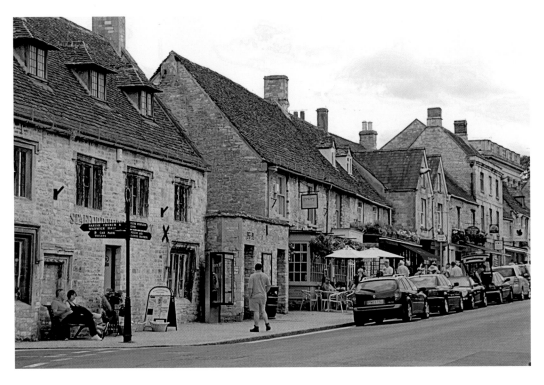

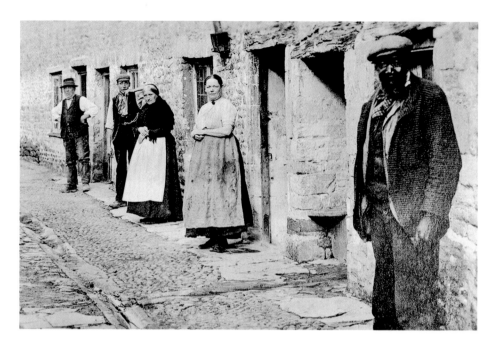

The College

Not academic, but a survivor of the many rows which once ran at right angles to the High Street. In the nineteenth century it had cottages and a lodging house. Nothing is known of the Afro-Caribbean gentleman. Left and right, with its medieval archway, one of many in Burford, as it is today.

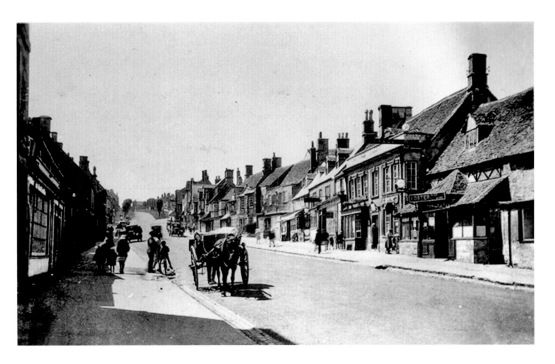

The Enterprising Mr Foster

Mr Foster was postmaster and pharmacist and in the early days of motoring he opened a garage on the right here, changing the front of the building to do so. For many years this was Mr Williams' antiques business but now it is part of the Oxford Shirt Company, together with Foster's shop and post office next door. Foster's garage doors (below) remain.

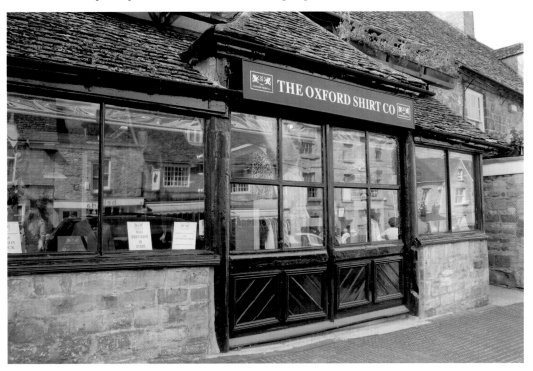

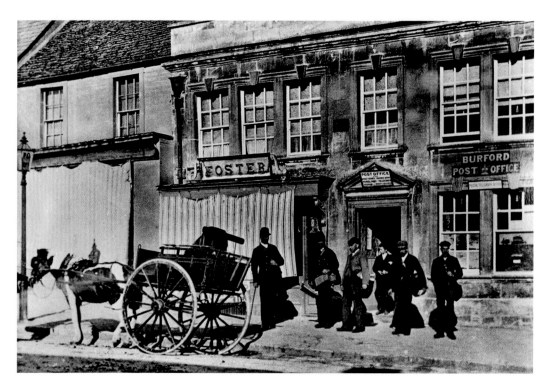

The Morning Delivery

This building must once have been a dignified residence, but in the early 1900s outside the Post Office and Mr Foster's shop, five postmen are about to set out and the mail cart is waiting.

Below, Mr Foster's garage, post office and shop as they appear today.

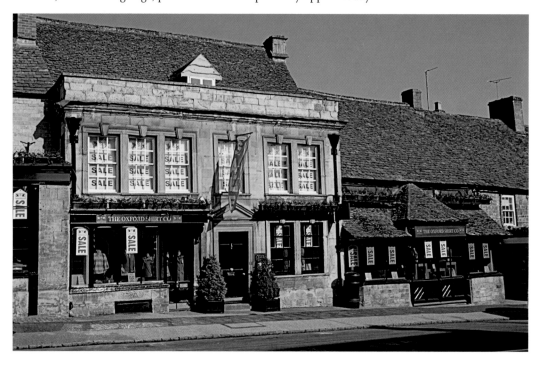

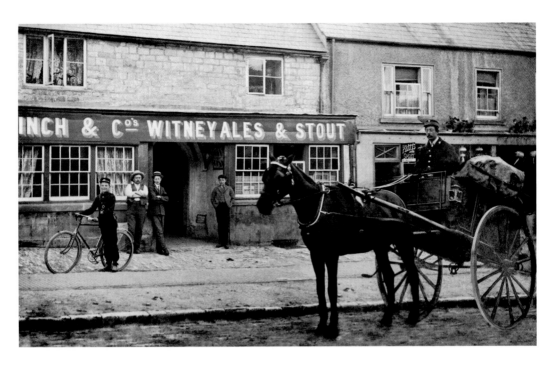

The Mail Cart Sets Out

The mail cart and the telegram boy are outside the Three Pigeons, the front of which was rebuilt between the wars to open as the Mermaid. To the right is Charles East's ironmongers' shop. When the ironmongers' business closed in the 1970s the double fronted shop was gutted to become the supermarket, revealing the frames of a row of cottages which once ran through here.

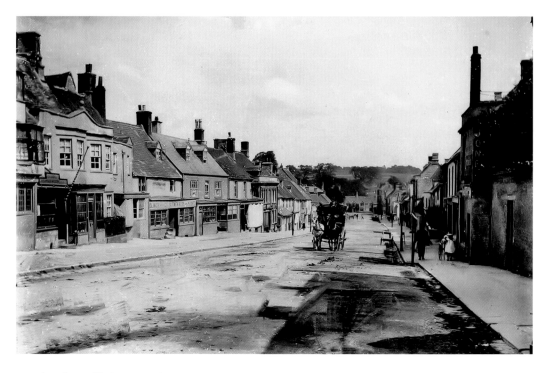

Another "Mood" Photograph

Mr Paintin's two horse omnibus returning from Shipton Station one morning before 1914 having brought his passengers and luggage the five miles over the downs. The gradients were a serious obstacle to Burford transport in the past.

Below, the same view today.

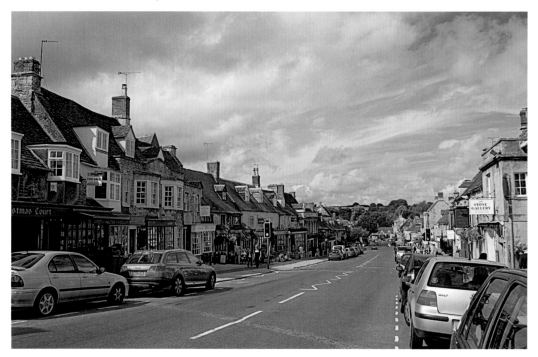

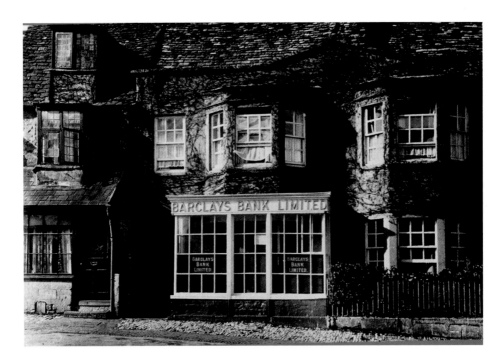

Financial Services

The local syndicates which in the eighteenth century provided Burford's finance merged into Lloyd's Bank which occupied premises on the High Street until in 1888 the bank was built in Sheep Street. Barclays arrived later and this house on the west of the High Street was its early premises before it moved to the Red Lion house, and later to new premises across the street.

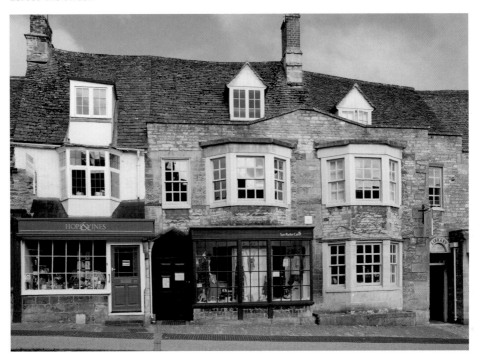

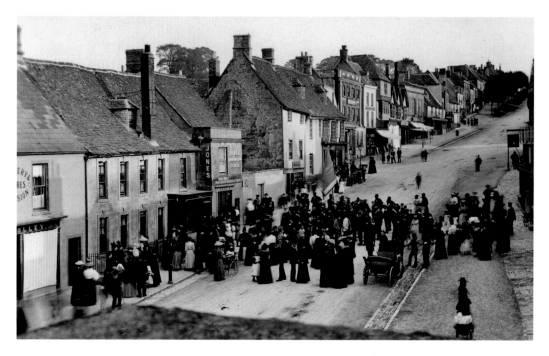

"Club Day"

This is said to be 'club day' in Burford High Street when the provident club or friendly society paid out its annual return. Burford had had such a society since the curacy of Alexander Dallas in the 1820s. This view shows clearly the gap left by a demolished house in which in the 1970s Barclays built their new premises.

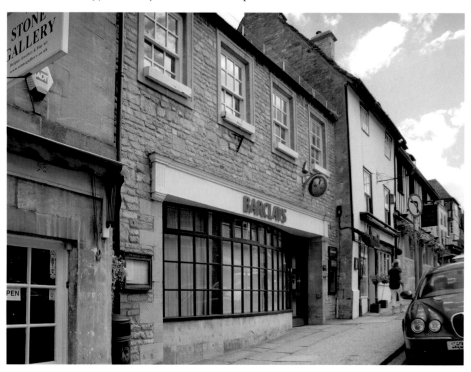

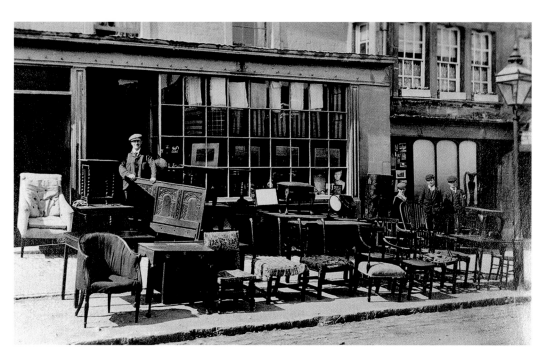

The Antiques Trade

Burford's antiques shops are well known though there are not today as many as formerly and there are more galleries. Here Mr Bowerman displayed his stock outside.

Below, Mr Fyson's window at night. The trade is more discreet now.

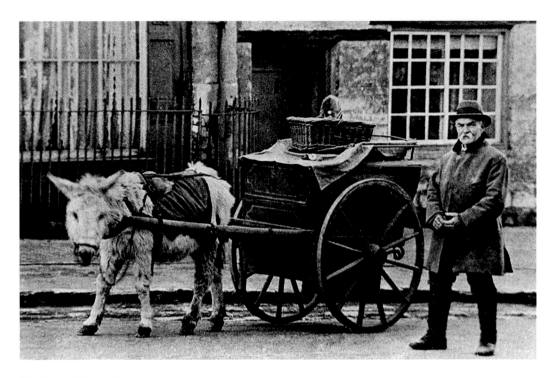

The Baker's Round

Daily doorstep deliveries of bread, milk, and many grocery necessaries were usual and the donkey cart was a familiar sight. Mr George Titcomb was the baker in Sheep Street into the twentieth century where his wife kept a sweetshop and his name survives on the house. His cart would have been in the middle of the picture below.

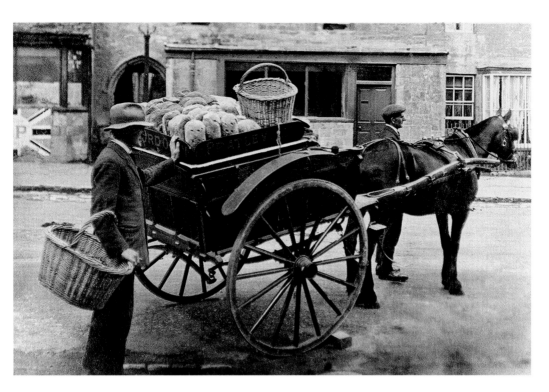

Mr Pratley the Baker

Burford had several bakers. Mr Pratley, whose horse and cart is here, was baker in the shop on the right, where later Mr Scott followed him.

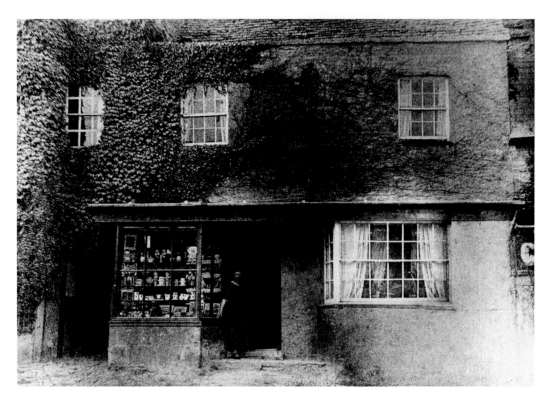

The Mermaid

This rather unsatisfactory photograph shows the property on the south of the Three Pigeons, now the Mermaid. Like most High Street properties it has fourteenth or fifteenth century details inside but received a new front in the twentieth century.

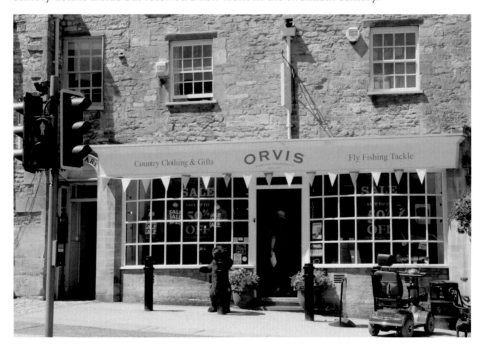

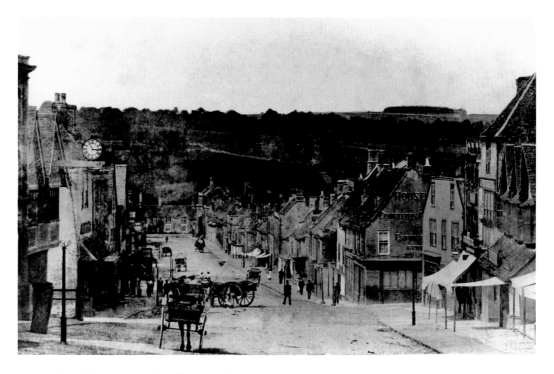

The High Street, Busier than Usual

Between the wars when traffic increased, the county had a plan to improve traffic flow through the town by demolishing the furnishers on the right and the pharmacy on the left, a plan defeated with difficulty. The furnishers, established by Westrope around 1840, was rebuilt as the hotel it is today, with the cut away corner in a token nod to visibility for traffic.

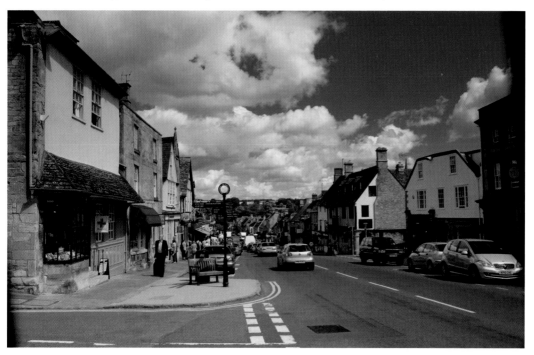

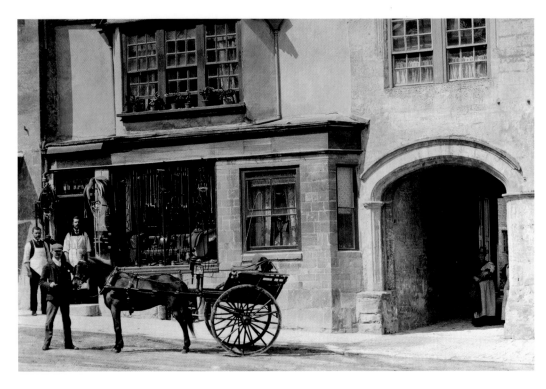

The Arch of the George and Wyatt's Saddlery Business

The George was here long before 1500, and the uphill third, standing on charity land, was added in 1608. The Bull and the George competed for trade, but in 1800 the Bull, fashionable and smart, bought the business and the George was closed, to be used for other trades.

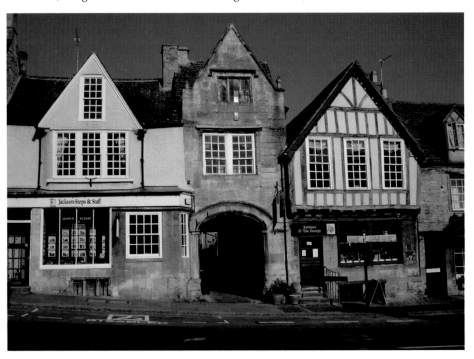

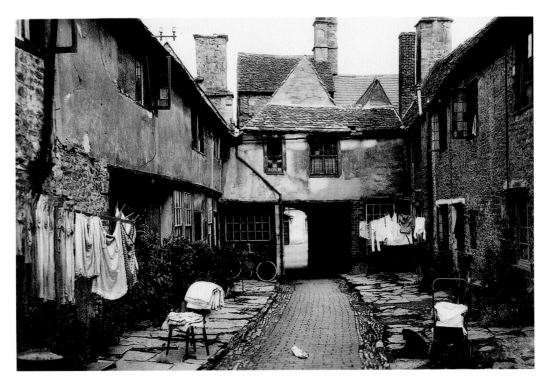

Washday in the Yard of the George Inn

As at the Bull and the Bear, coaches could drive through without turning and emerge into a side street. When the inn closed in 1800, the yard with the stables was used by the mason John East, and it later became cottages. The cottages were bought by public subscription in the 1960s, improved and handed over to a housing trust.

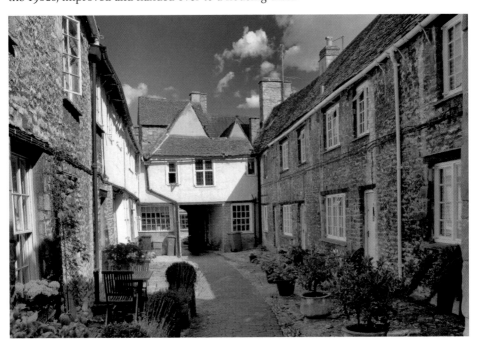

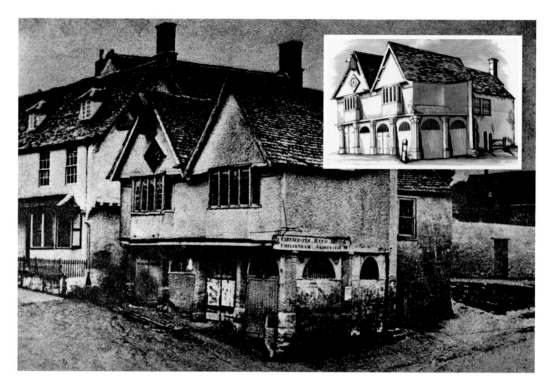

The Tolsey, the Old Market House, Built around 1520
This unclear early photograph is dated to 1860. Inset is a much clearer drawing from Fisher's small book of 1861, showing the diamond clock face, and the stocks and the whipping post for vagrants. Long before 1860 these were disused survivals like the lock-up behind them.

Below is the Tolsey today, restored and reconstructed in 1958.

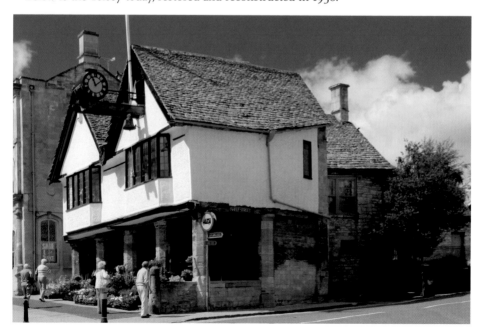

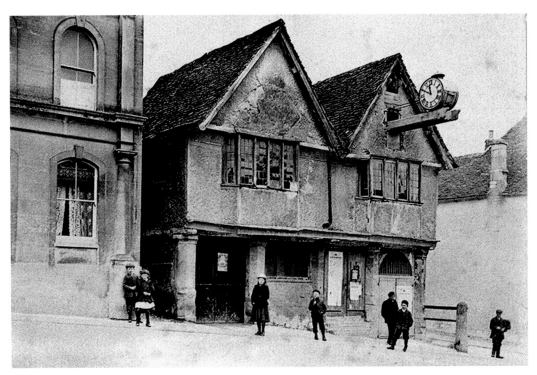

The Tolsey in Disrepair

The Burford Corporation was abolished by Act of Parliament in 1861 and its properties made over to a new body of charity trustees. The legislation was flawed, making no mention of the muniments or of the Tolsey, which was not a charity property and on which therefore no money could be spent. As a result as shown here it fell into disrepair and it was some years before the new Council, founded in 1894, could obtain a lease of it. Only recently has it been formally handed to the Town Council. The horse drawn fire engine was kept in the left hand space, there was a central staircase, and charity bread was weekly distributed from the right.

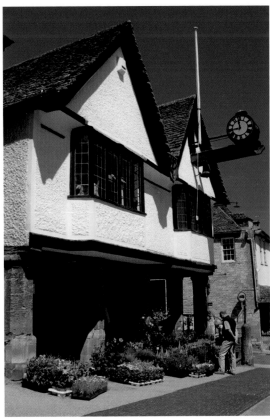

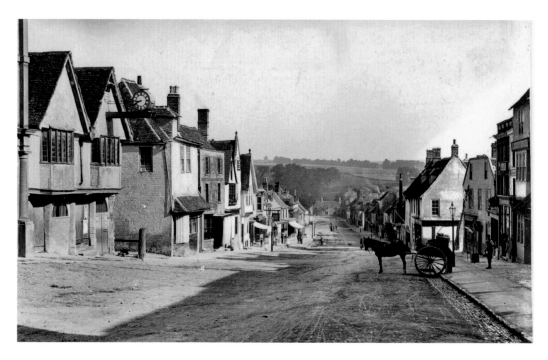

Looking North and South

These two pictures looking north and south were taken on the same morning around 1890 at 8.34 and 8.41 while the horse waited patiently. Looking at these views it is easier to credit that from time to time a boy would emerge from Wall's rope works behind the buildings above the Tolsey and walk backwards across the High Street twisting the rope as he went.

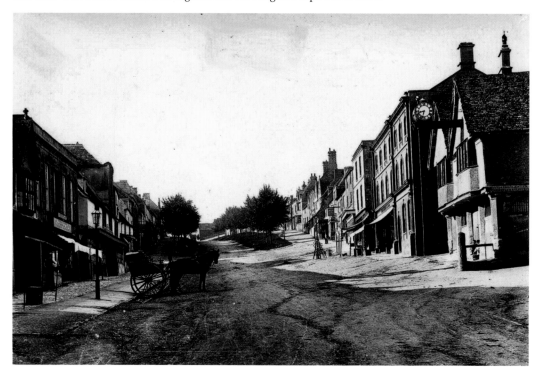

A Thirteenth-Century Site

In the Middle Ages at market and fair times traders would put out a shallow temporary "shop" on the front of their property. This soon became permanent, and in time became part of the building, the front wall above as here being carried on columns. Then the process begins again with canvas awnings. Page 44 shows the process well.

This property though not, of course, the building, is Burford's oldest documented site, being named in a parchment of 1250 bearing the town seal. For over two centuries the Holland family were ironmongers and gunsmiths here, and the ironmongery business continued with Evans and then the Taylors, father and son. In the changed world of Burford's trade in the 1990s it became an interior decorator's business as workaday shops were replaced by specialist providers.

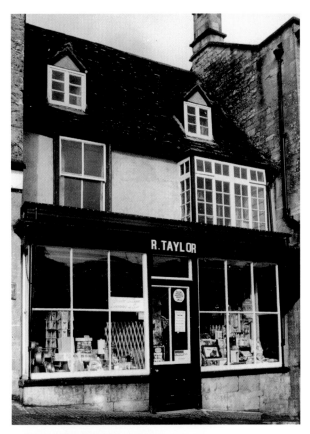

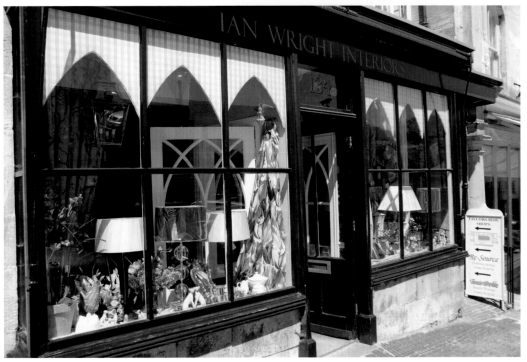

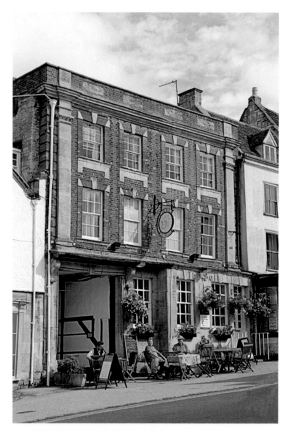

The Bull and Touring the Cotswolds

This is Burford's oldest inn in continuous trade, going back at least to 1500 and has been on its present site since 1610. It has Burford's only brick front, a gesture to fashion in the past. Before cars and caravans, around the turn of the century there was a fashion for bicycle clubs and bicycle touring. Several Burford houses offered not only teas but carried the sign of the Cyclists Touring Club offering accommodation. Here is a group outside the Bull out for a run on Good Friday 1901. It is difficult now to see either their garments or their machines suitable for the gradients around Burford.

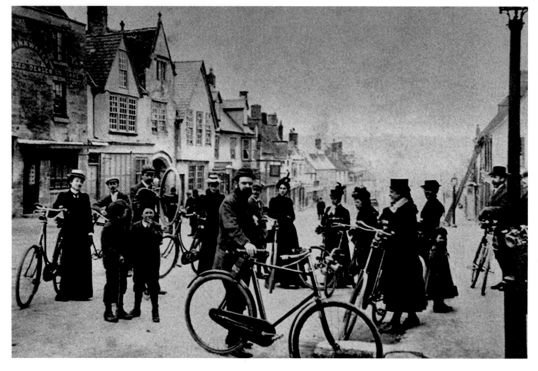

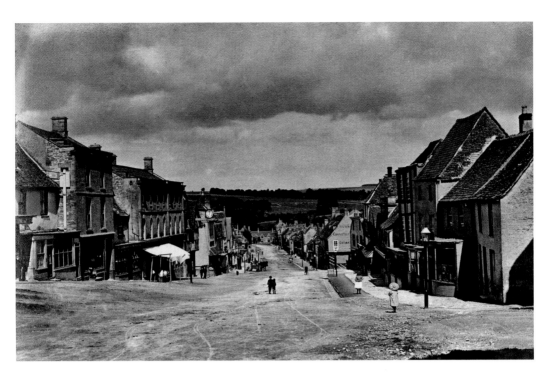

A Quiet Day around 1900

The property on the extreme left was the ironmongery business of the Holland family who were also gunsmith's two doors below. It has since been seriously altered. On the right the roof of what is now the Highway Hotel was raised by a storey after the date of this photograph.

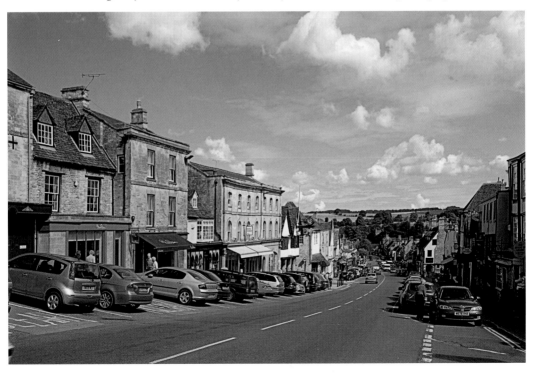

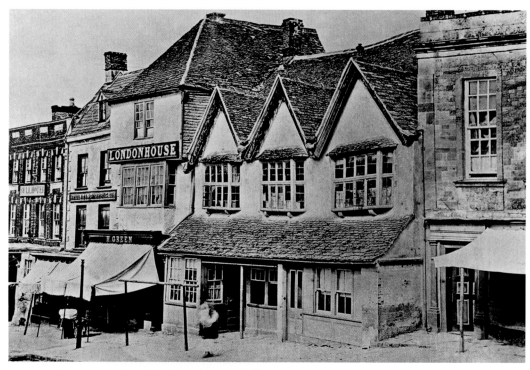

Houses of Character

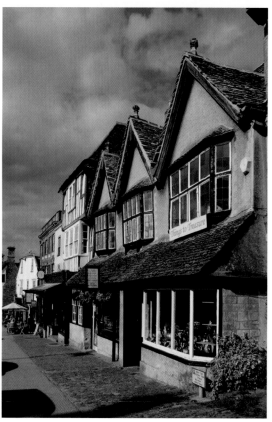

Almost all the properties on the High Street have medieval work inside, but these retain their older fronts as well. London House possesses a fine vaulted undercroft. The three gabled building from before 1500 was the Bull until it moved to its present site in 1610. Before long the property was divided, and the uphill third was the Wheatsheaf until the 1870s. Notice here as on many Burford buildings the single storey "shop" extensions mentioned on page 41.

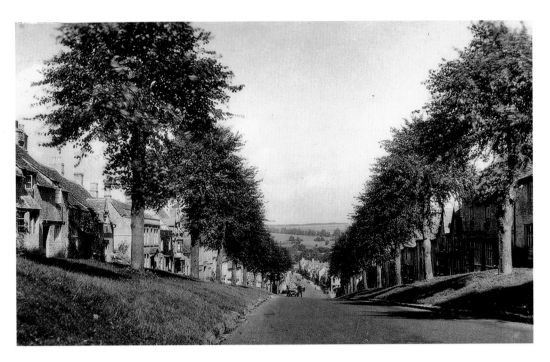

The Hill

Centuries of use have eroded the road leaving the houses standing above the grass banks. Burford's hill was formerly steeper than it is now but in the 1970s the gradient was smoothed, the brow of the hill moved south and the banks became steeper. This is a view of Burford that visitors cherish.

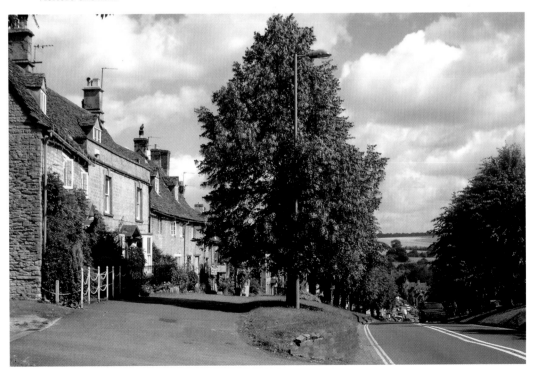

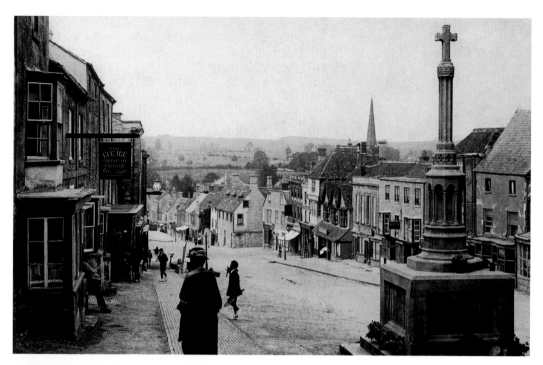

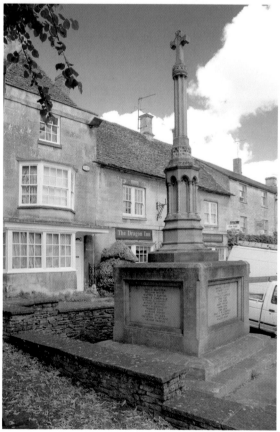

Loss Remembered

The War Memorial was placed on the hill in 1920. The names of thirty-six lads from the desperate years of 1914-1918 and nine from 1939-1945 who grew up on these streets but never came back to them are recorded here and remembered every November. The sign to the left is the New Inn, later after the Second World War to be the Rampant Cat (a jest on the town seal) and now the Dragon.

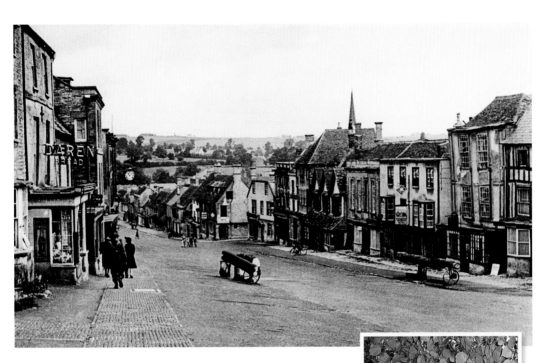

Wartime Again

Burford took its war preparations seriously. With air raids in mind two emergency mortuaries (the barn behind the Lamb and the cemetery chapel) and a casualty clearing station (the hospital) were prepared by 1938. In the event of invasion pivoted tree trunks could be swung in several places to block all the roads. A concrete "pill-box", now very overgrown, (right) was built below Westhall Hill to command the bridge. Neither air raids nor invasion came but by 1944 it was said that the town was a centre for 4,000 troops before D-Day.

Below are the bases of military huts remaining in the Old Vicarage garden around 1950.

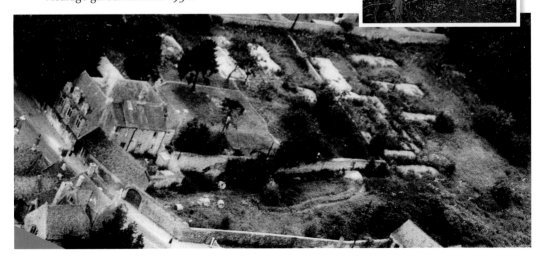

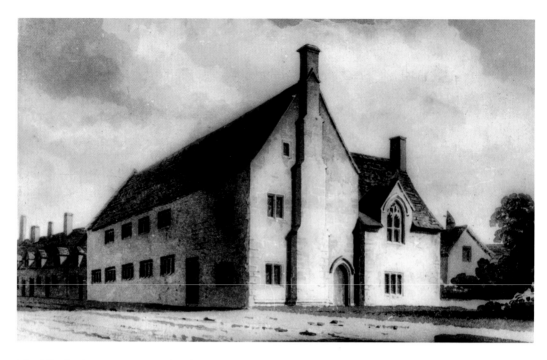

The Elizabethan Grammar School

This is another 1821 drawing by J. C. Buckler. It shows the 1571 building with the master's small Gothic house behind it, and the cottages in Church Lane beyond. The string course on the modern view shows where the roof has been raised and its pitch changed. The master's house was demolished and replaced by a larger plain block in 1868, and in 1888 the tall block beyond was added. The cottages on Church Lane went in the 1890s when a science extension was built.

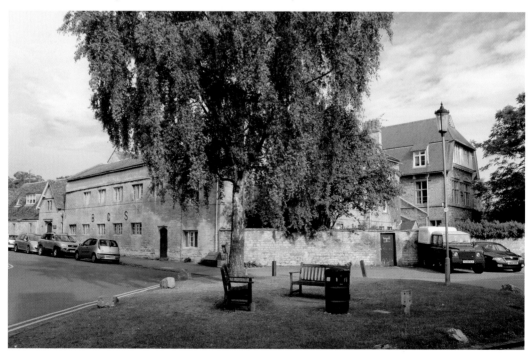

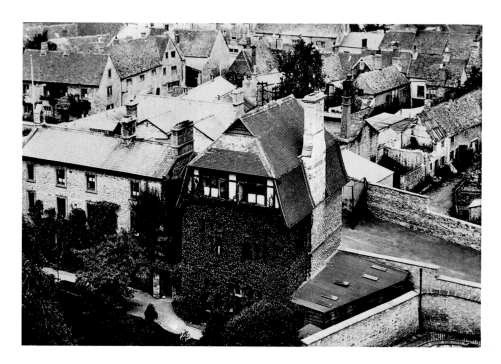

A View from the Church Tower

The school's extensions of 1868 and 1888 are in the foreground. Behind are the gas works, with the circular gasholder visible in the centre distance and the coal and coke stores in derelict cottages. The gas company, founded in the 1860s, ceased trading in 1916, but the site was not totally cleared until 1924 when the land was acquired for the school.

Below you see it as it is today.

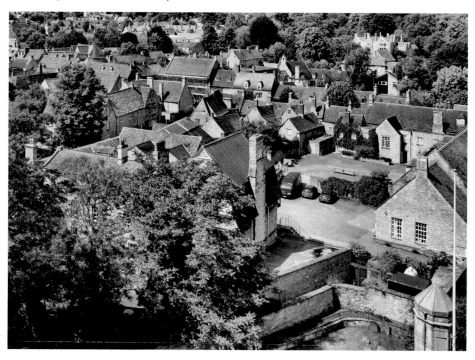

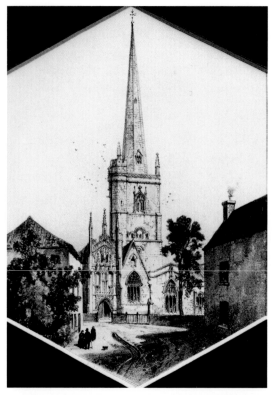

Church Green in the early 1800s
The house on the left is where the Misses Pritchard conducted their school for young ladies. On the right is an important house lived in by the merchant John Templer in the early 1600s and later by the surgeon William Chavasse. It was rebuilt as the church school for girls and infants in 1863. All primary education has been conducted in Priory Lane since 1914 and the church school became the Church House, was reconstructed in the 1960s, and renamed the Warwick Hall when it was leased to the Town Council.

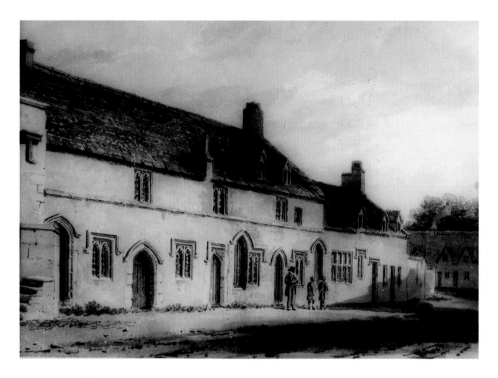

Another Buckler Drawing

The almshouses were founded in 1457 by Henry Bishop, and the string course suggests that originally they had only a single storey. The important house standing until 1863 where the Warwick Hall is now projected out beyond the present building line and its large mounting block is seen on the left. In the nineteenth century the building beyond lost its Gothic details and received sash windows.

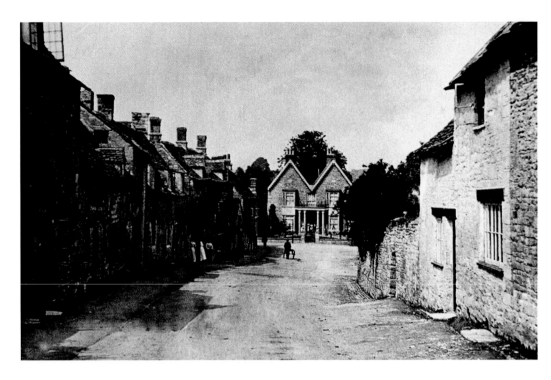

The Guildenford

Tiverton Villa, built in 1888, closes the view. Most of the cottages on the left have been demolished and rebuilt and the Byway Garage founded by Mr Vick in 1928 is now on the right. Past Tiverton Villa is the new bridge into the car park established in the 1970s on the field called Bury Orchard.

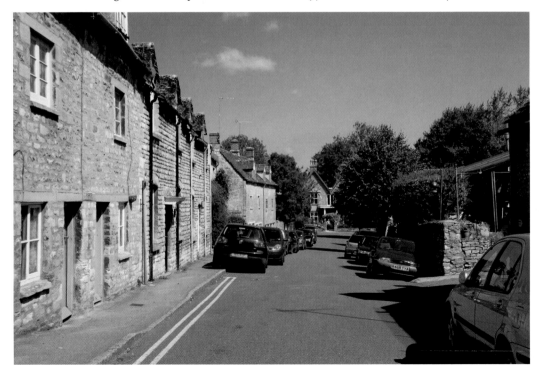

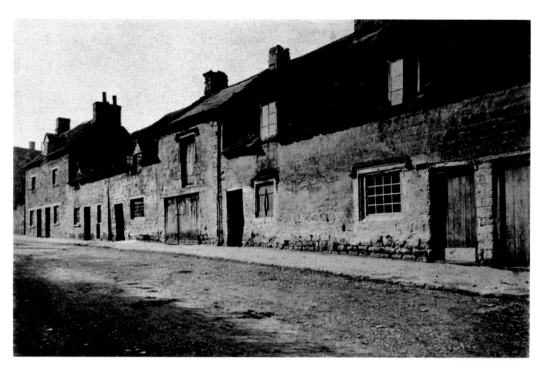

The Guildenford Again

These vanished cottages on the west side were typical of much vernacular building in the side streets of Burford in earlier centuries. The parking on both sides of the Guildenford makes a frontal view now impossible.

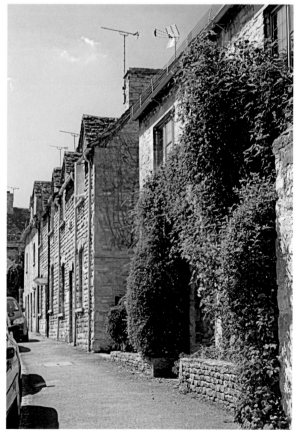

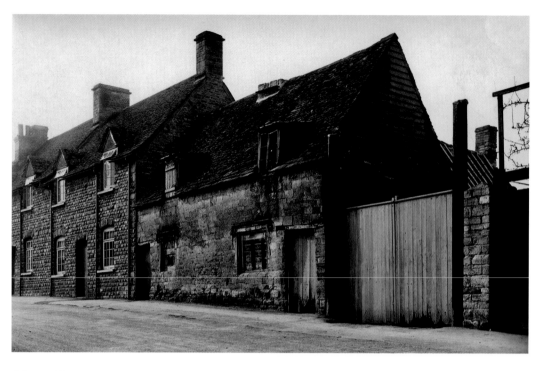

A Later View

Some demolition and some rebuilding had already taken place. To the right of the picture is now the garden of the new Vicarage, built on the corner in 1937 to the design of the Burford architect Russell Cox and since enlarged.

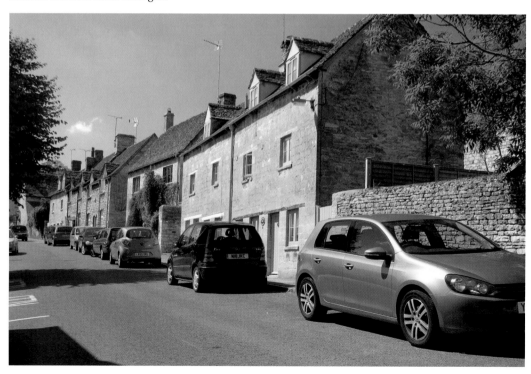

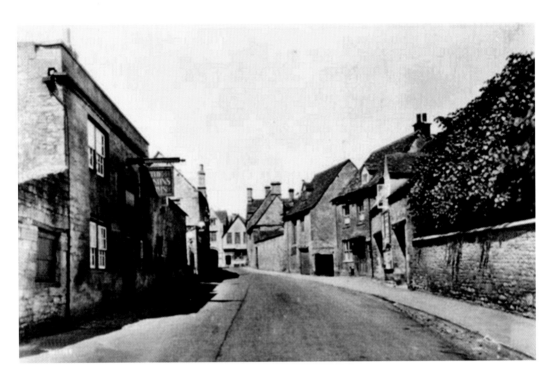

Witney Street toward the High Street
Where there was a blank wall on the right is now the entry to Sylvester Close, built in the 1970s on much of the former garden of the mansion which became the Methodist Church. The Masons Arms is now the Angel and the gap on the left where a former bakery had been demolished is now filled with a new house in traditional style.

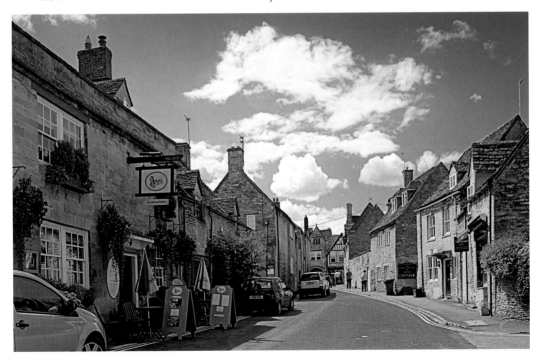

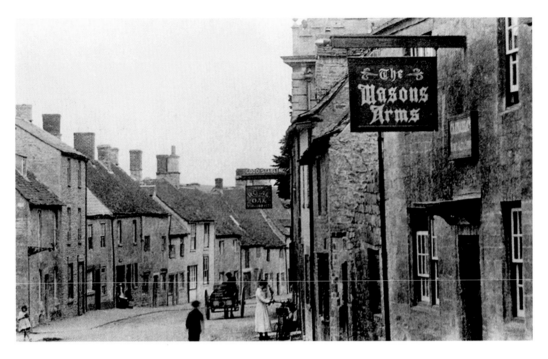

Looking East along Witney Street

The Masons Arms became the Angel in the 1980s reviving the name of the inn that stood on the Witney Street corner in the sixteenth century. The sign of the Royal Oak can be seen beyond on the corner of Pytts Lane. As everywhere in Burford, former artisan cottages have been transformed.

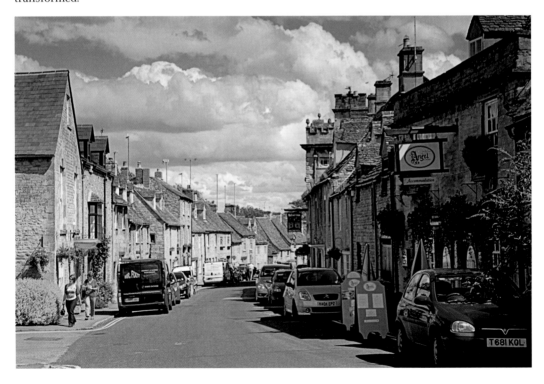

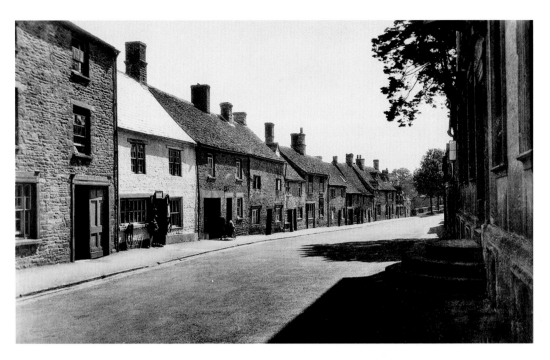

The North Side of Witney Street

On the left is the eighteenth-century White Hart inn, now a private house. Next to it is Bowl's saddlery workshop. The steps of the Great House which dominates the south side of the street are seen on the right.

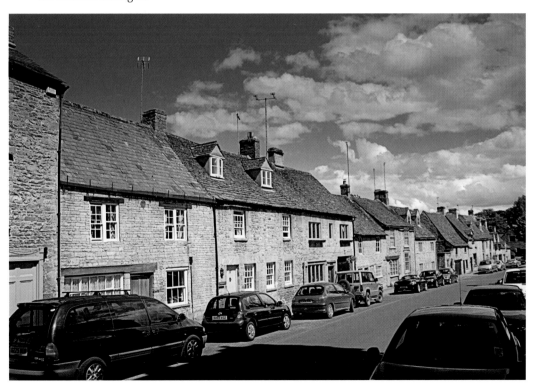

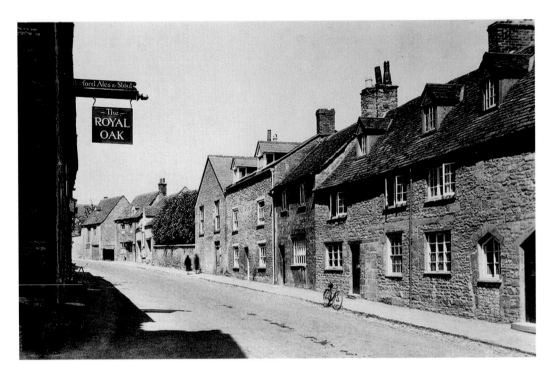

Witney Street Looking West

Where the Royal Oak is now was once an ambitious new inn built by Richard Merywether in 1615 with a sign of a White Hart over the road. The inn did not last and Merywether went bankrupt. The taller building on the right was formerly the Plymouth Brethren meeting house. Skips, like parked cars, are also part of the Burford street scene.

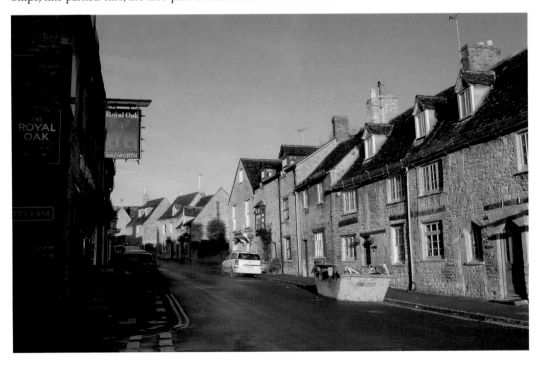

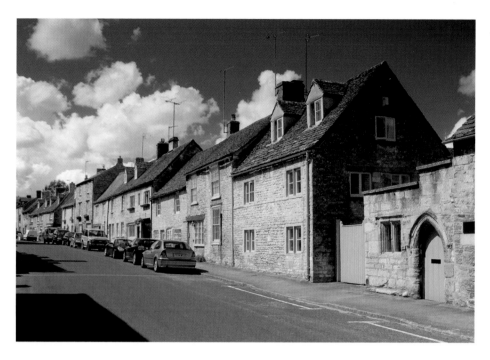

Bell Founders in Burford

The Neales were here in the seventeenth century, but in the nineteenth and twentieth the Bonds are remembered, first in Sheep Street and then here behind the arch on the right where a building has been lost. This is Tom Bond with his handiwork.

Below is one of Bond's bells in Burford's church tower, where the oldest of the eight bells dates back to around 1330.

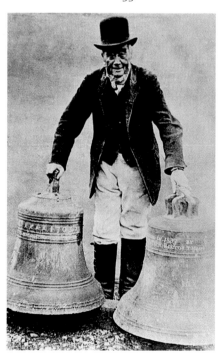

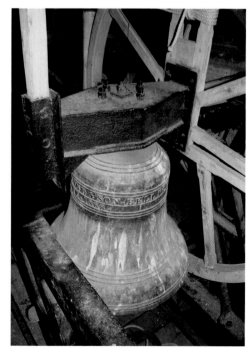

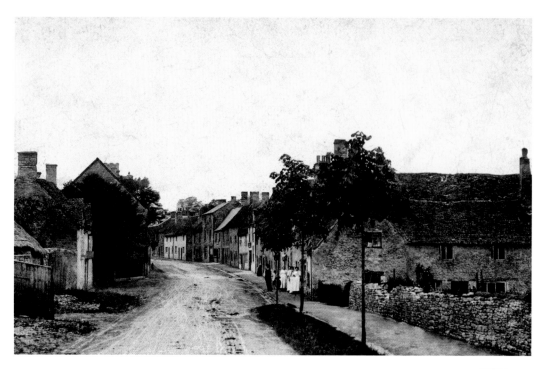

The Entry to Burford

The eastern end to Witney Street around 1900. Leather Alley, once inhabited by workers at the nearby tannery, ran down to the right. Burford was famous for its leather trades. This was formerly the beginning of continuous building, but now it extends on the left with the new Fire Station and traditionally built bungalows.

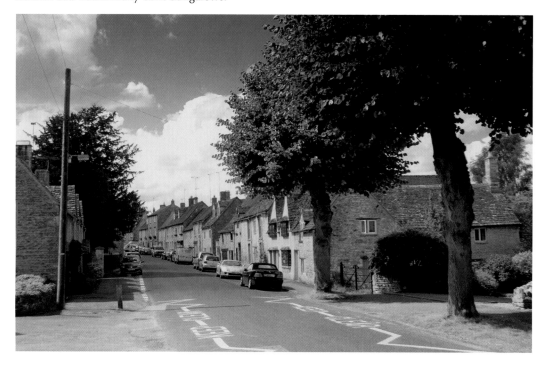

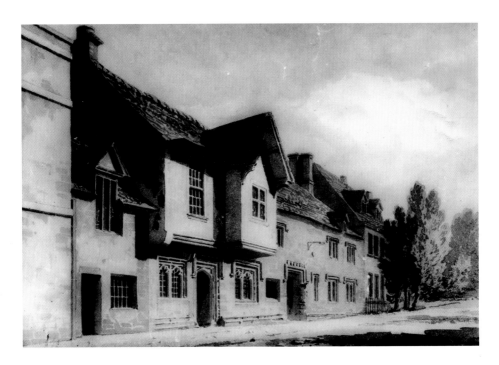

Sheep Street

Another drawing by J. C. Buckler in 1821. This is of the house in Sheep Street named Calendars by the Grettons, writers on Burford, who lived in it from around 1912. The Little House beside it is now part of it. The Grettons were responsible for stripping the parging from the house but the alterations to the roof line were before their time. A house to the right has vanished.

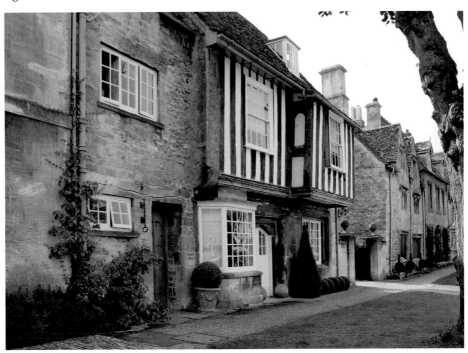

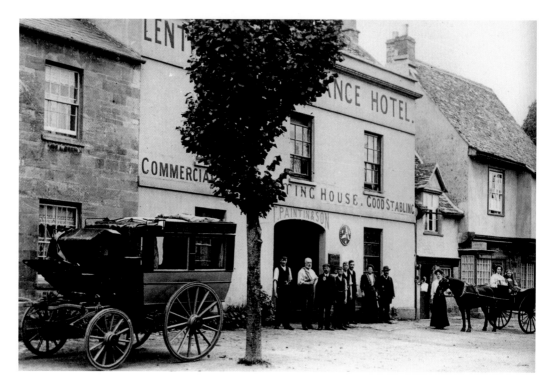

The Transport Business

Thomas Paintin was a strong Methodist who opened his Temperance Hotel in what had been the Greyhound Inn. From these premises he ran his horse-drawn business with coaches, a waggonette, hansom cab, dog cart and a glass hearse. He boasted of his regular service to Shipton station that he never missed a train.

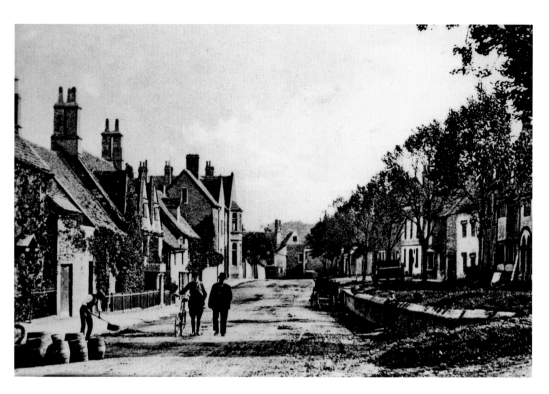

Sheep Street
Barrels stand outside Garne's Brewery. I am told that the two figures are Burford's Dr Cheatle and Mr Wingfield who has ridden in from Barrington Park. Cycling was then a gentlemanly recreation.

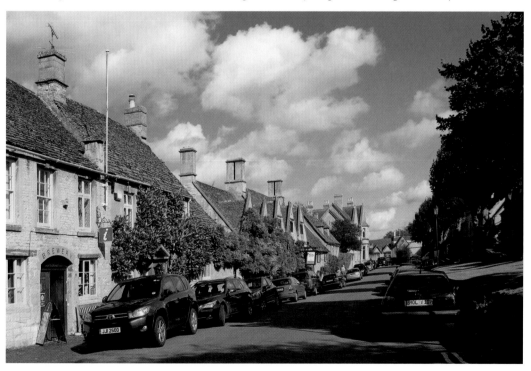

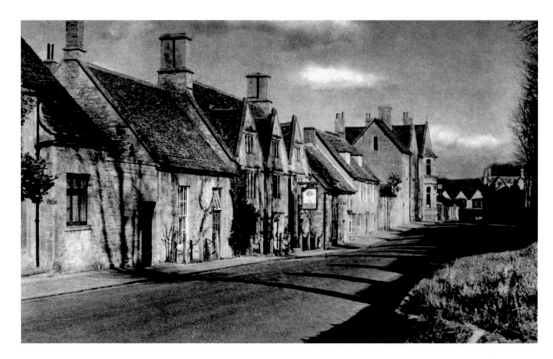

Sheep Street Again

Miss Sylvia Gray established the Bay Tree Hotel in the 1930s in what had been for centuries a solicitor's house on the corner of Lavington Lane and Sheep Street. In this picture from before the war Miss Gray had not yet converted the building on the left, adding to it two matching gables. Lloyd's Bank building from 1888 is towards the High Street.

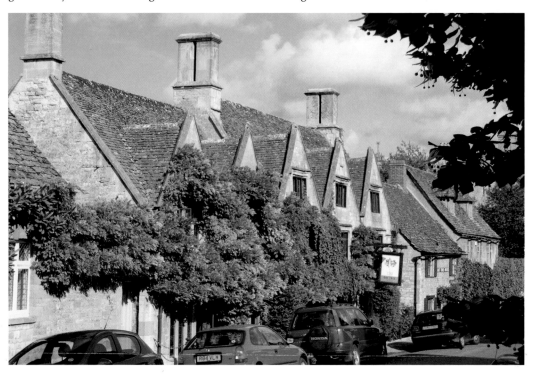

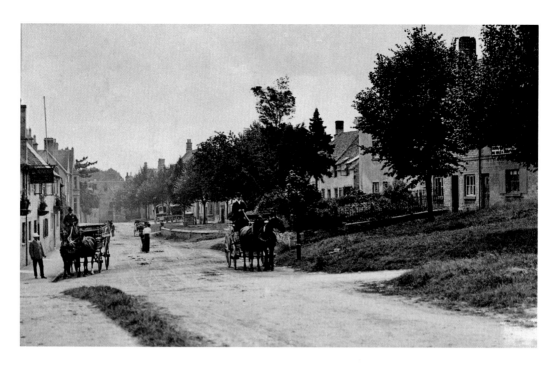

A Quiet Street

The broad banks of Sheep Street in past centuries had at market and fair times housed hundreds of sheep for sale, but in the agricultural depression after 1870 the market collapsed and Sheep Street became quiet indeed. Now it is conspicuous for its two hotels and the density of parking on both sides of the road.

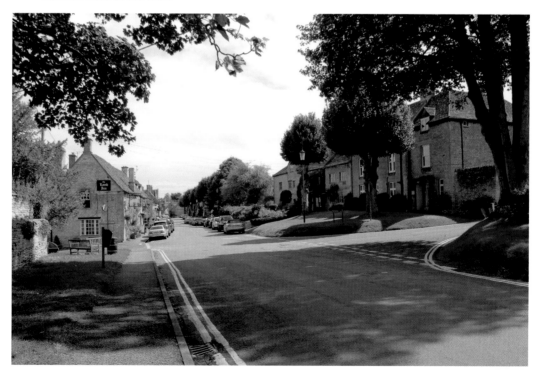

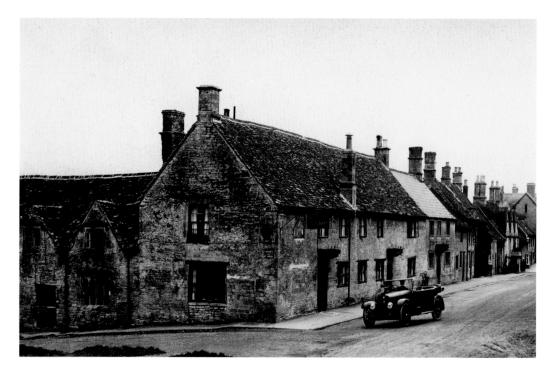

The Lamb Inn

The Lamb Inn was created between 1720 and 1734 from earlier cottages and a medieval house and barn behind. The distinctive sign today was the work of a local whitesmith, Benjamin Richards. This picture is from around 1930 before a further house had been entirely incorporated into the inn.

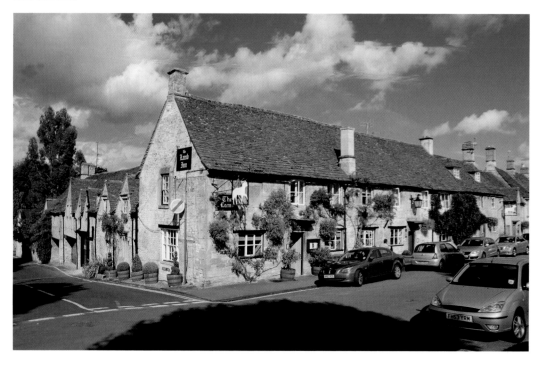

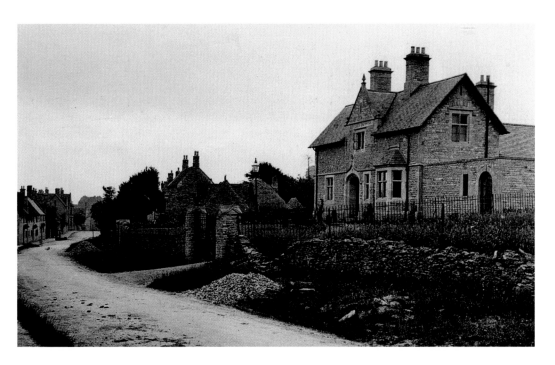

At the End of Sheep Street

Burford's own hospital began in the large old building in Church Lane now School Foundation property and called the Cottage Block. A new hospital was erected in 1904 at the end of Sheep Street and in later years very much expanded. It passed to the NHS after the war and in spite of local indignation it was closed a while ago.

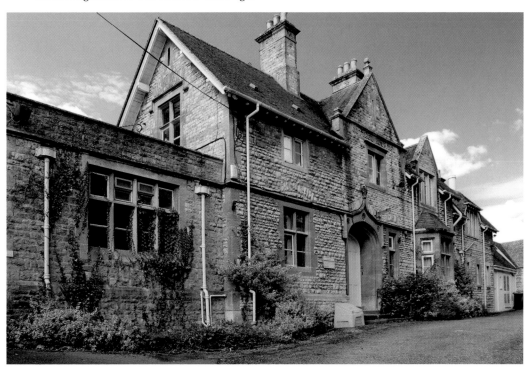

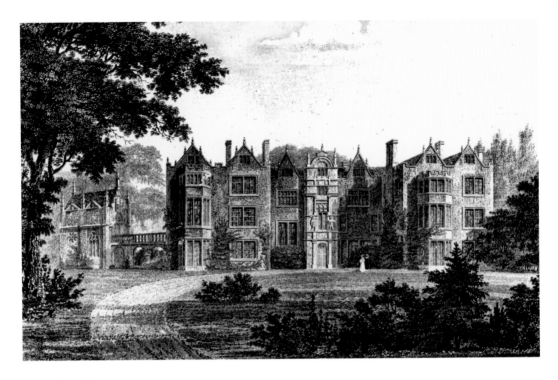

The Priory

After the Dissolution the medieval religious house was rebuilt as a mansion. This engraving was published by Skelton in 1826 and shows Burford Priory before the last of the Lenthalls, attempting economy, reduced it in size. From 1949 until 2008 it was again the home of a religious community, but is now a private house once more.

Below, the figures over the door.

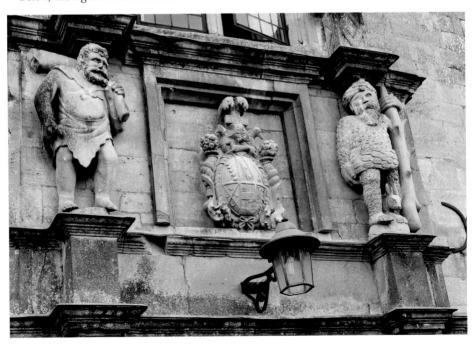

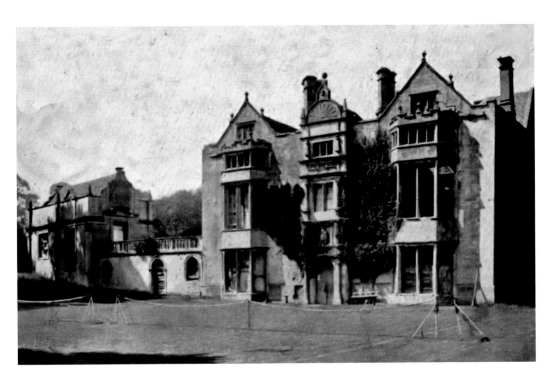

A Derelict Mansion

Six generations of Lenthalls had lived in the Priory but when the manor was sold in 1828 the new owner had no use for the house. It stood empty and the ground was used for recreation by the town. It was sold in 1908 to Col. La Terriere who started the restoration and then again in 1912 to Emslie Horniman who completed it. The top photograph is early, the lower one shows a later stage of decay.

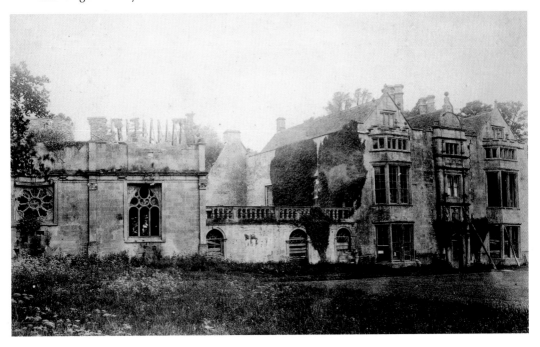

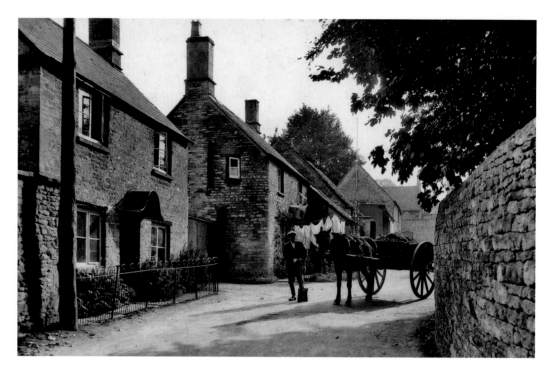

Cleaning the Streets
This is a corner in Priory Lane. The corners of the side roads of Burford preserve something of the medieval grid plan of the town. With horse traffic the streets always needed cleaning. The house on the left was rebuilt in the 1970s.

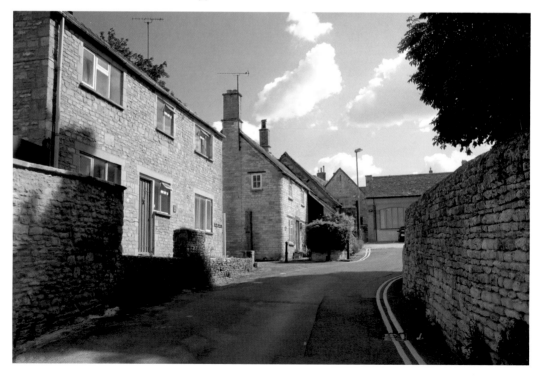

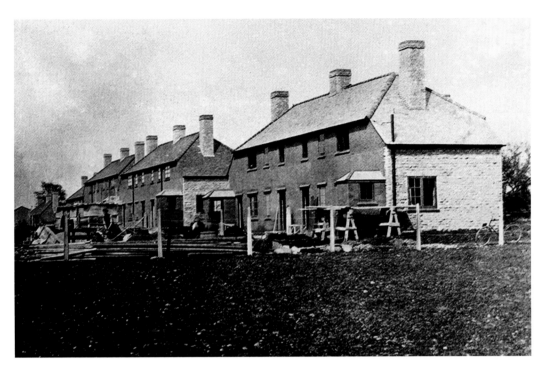

New Building in Burford

Local government building in Burford began with these houses on the Leaze after 1919. It continued on the Oxford Road, in Frethern Close and, after the second war, along Swan Lane and Witney Street in traditional style. Most of these houses are now privately owned.

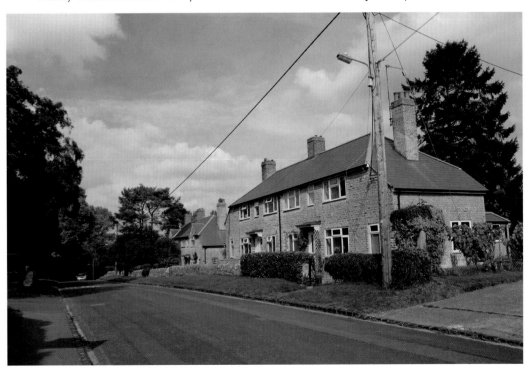

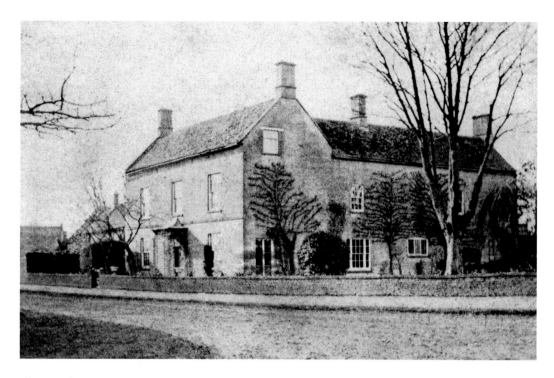

The Farmhouse at Bury Barns

The Burford Golf Course was established between the wars and this important eighteenth century farmhouse became the first club house. It was demolished when the roundabout on the Oxford-Cheltenham road was made and a new club house was built on the course further to the south. It is difficult now to imagine this area as it was before the roundabout.

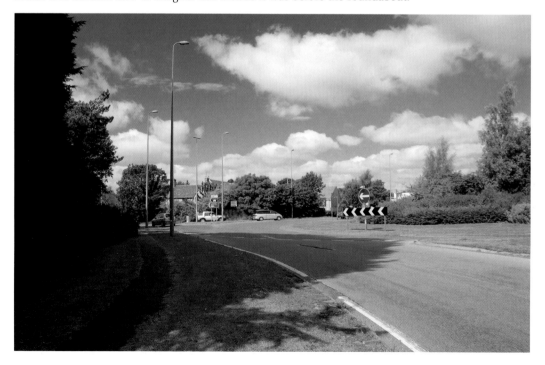

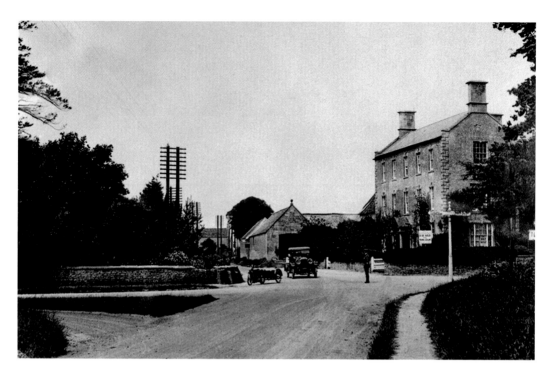

The Cross Roads

The road at the top of the hill around 1930. The road between here and the Cirencester turn was straightened at this time and the buildings beside the road, outbuildings of the hotel visible behind the cars, were cut back. An AA man is on duty at the crossing. Notice the telephone pole carrying multiple wires which now go underground.

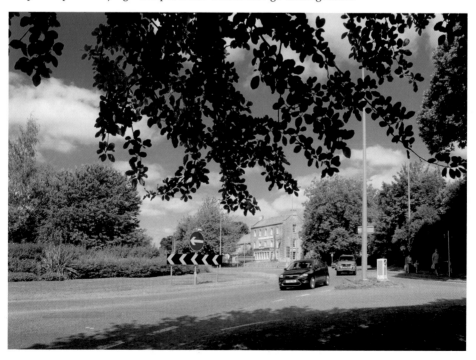

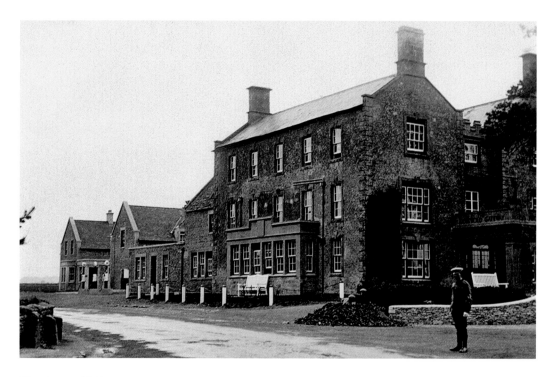

The Cotswold Gateway

Mr Faulkner who farmed at Bury Barns promoted this as the turnpike road around 1814 sparing the horses the gradients through the town. His Bird in Hand Inn catered for the passing trade. With the decay of the coach trade the inn closed but reopened as the Cotswold Gateway Hotel in 1928 when motoring arrived. After the war Paine and Pearman established a garage business in the outbuildings beyond the hotel.

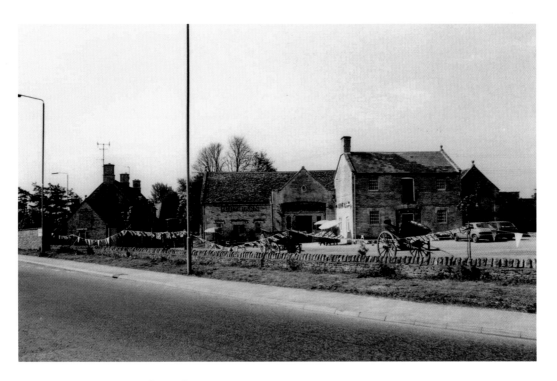

A Landscape Transformed

Only the Cotswold Gateway and the large traditional barn in the centre of the picture survived. It was once the scene of popular celebrations and in the 1960s it was used for town dances and receptions but now it has become a roadside eating house with a 'motel'.

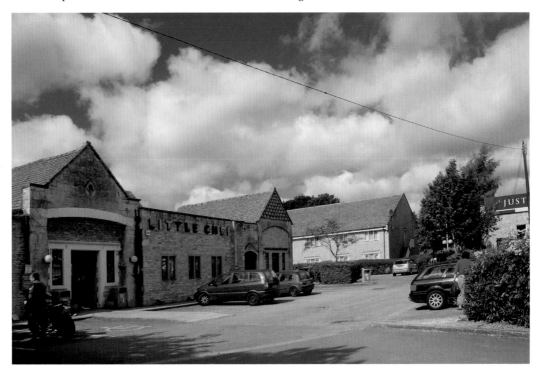

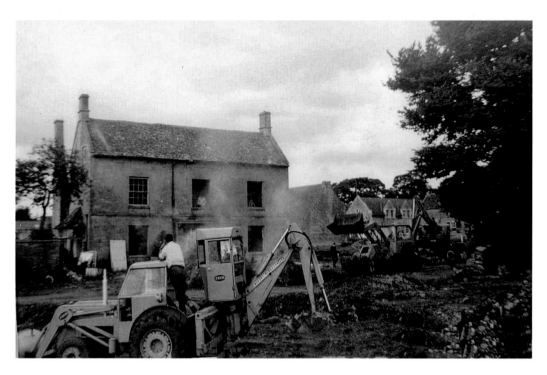

History Swept Away

With the farmhouse and cottages demolished, Bury Barns, the manorial centre at the top of the town, has gone. Many a traveller on the A40 road is unaware now that he has completely passed Burford by.

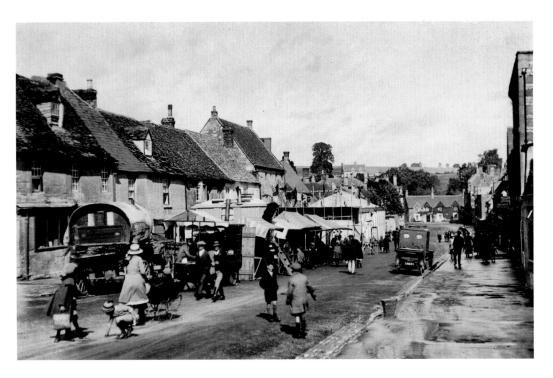

Fair Time with Showmen's Caravans and Stalls

Burford's medieval fairs were great commercial occasions, lasting at midsummer for fourteen days and attended by Italian wool merchants. In time these faded into the farming markets and then into fun fairs and have now disappeared altogether.

Below, the street today.

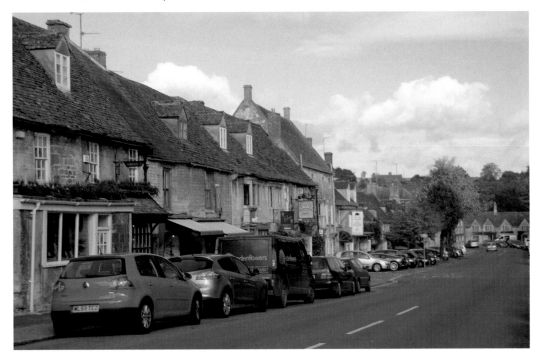

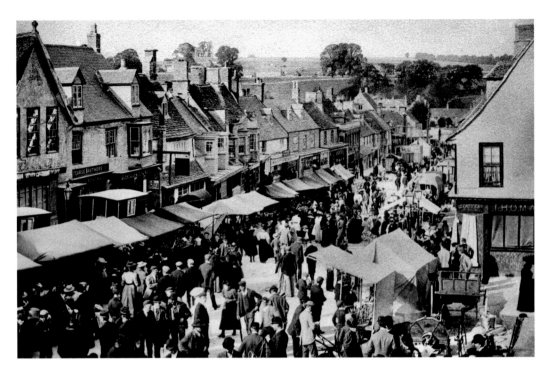

A Century Ago

The crowds in Burford for a fair at the beginning of the twentieth century. The stalls were set up along the west side of the High Street and in Priory Lane on Friday evenings and were gone by Monday morning. By the middle of the century the stalls did not come as far up the town as this.

Below, the workaday High Street.

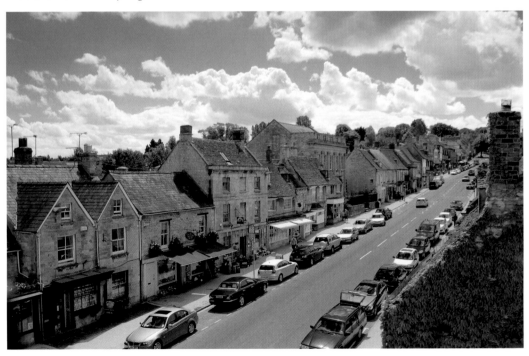

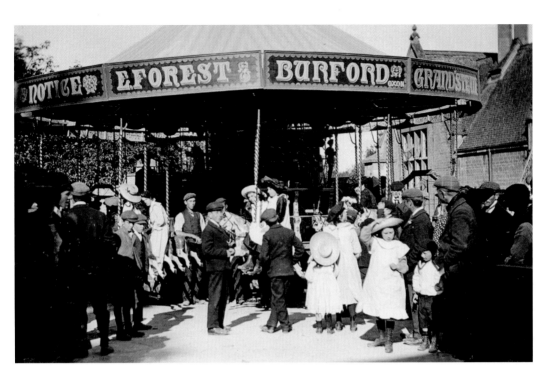

Roundabouts and Swings

The Forests were one of the traditional showmen's families which settled around Burford. Their entertainments had a style of decoration that was all their own. Priory Lane was wide enough for a roundabout outside the school.

Below, an occasional street market in Priory Lane today.

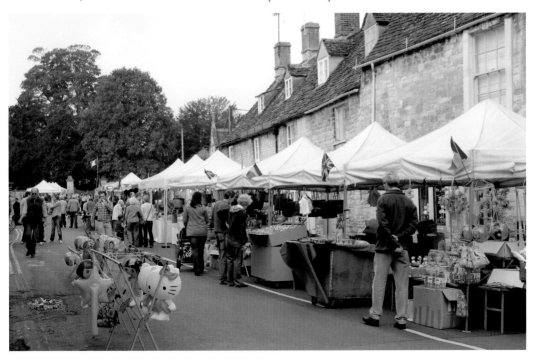

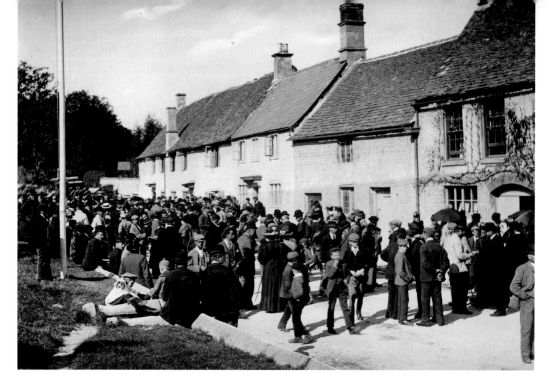

The Hiring Fair

Annual contracts of employment were arranged and sealed with a shilling at hiring fairs in September as the agricultural year came to an end at Michaelmas. Carters came with a knot of whipcord and shepherds with a twist of wool in their lapels. This gathering in Sheep Street, suspiciously near to the Brewery, is said to be such an occasion.

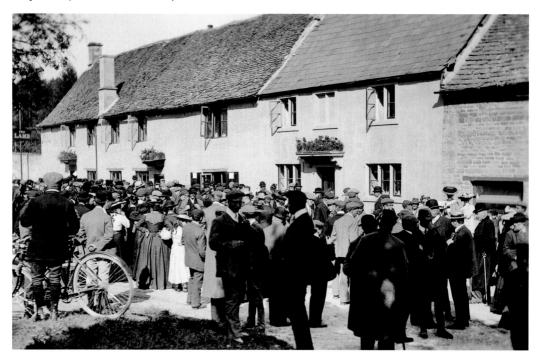

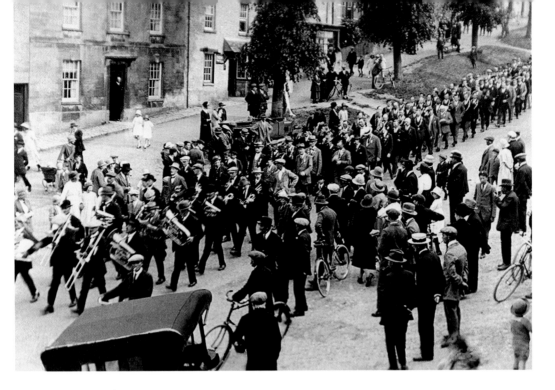

Church Parade

The Royal Antediluvian Order of Buffaloes was a social and charitable organisation founded in the 1820s and formerly widespread across the country. The Burford branch of the Wychwood Lodge met regularly in the New Inn. Here the Wychwood Lodge is parading behind the Town Band to their annual church service.

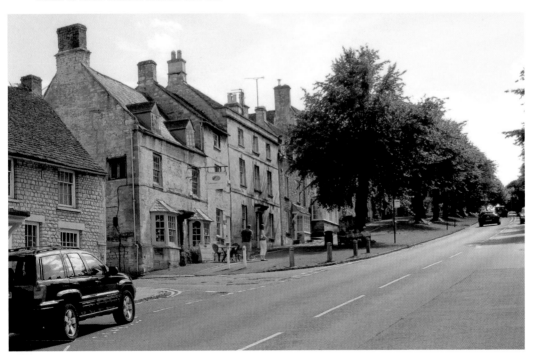

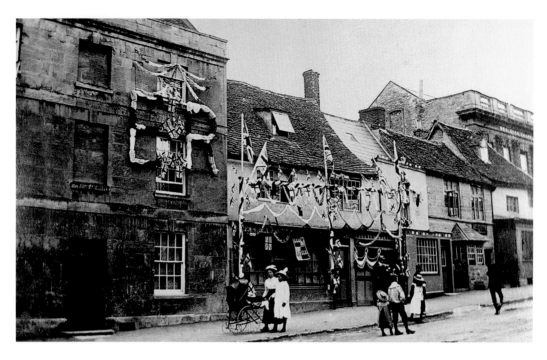

Coronation Time, 1902
Queen Victoria's Golden and Diamond Jubilees had given the country a taste for celebration, and for the coronation of Edward VII, delayed by his illness, many Burford properties were decorated like these.

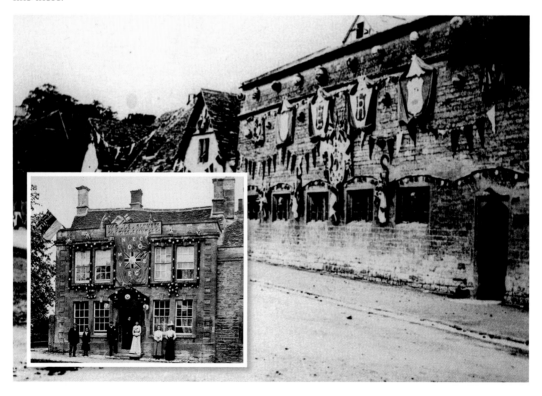

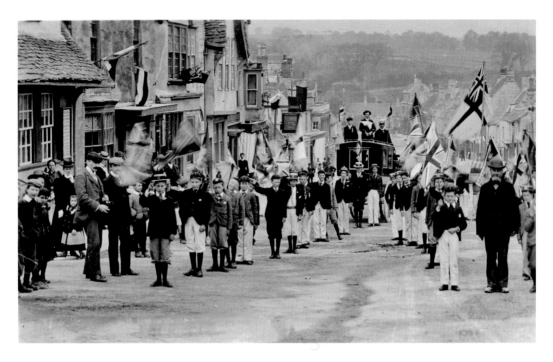

Mafeking

The South African War beginning with a series of reverses had proved a bad shock to national morale and when the besieged town of Mafeking was relieved in 1900 a wave of rejoicing swept the nation. Here some of the boys and masters of the Grammar School are demonstrating their patriotic enthusiasm on the High Street.

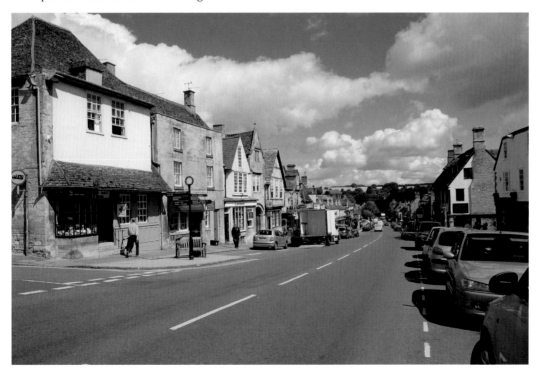

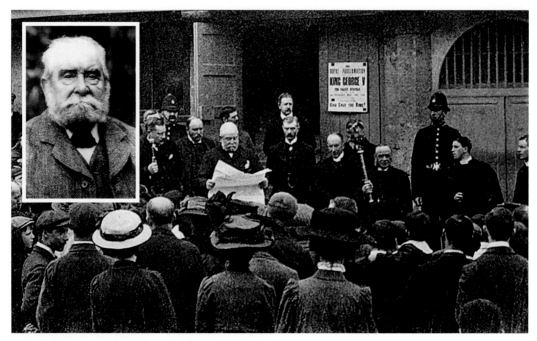

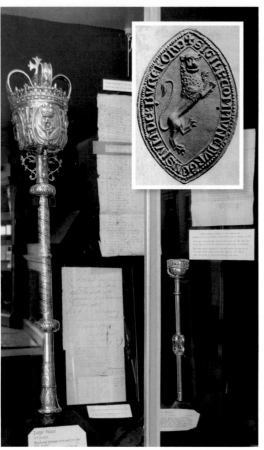

A New Georgian Era

Charles East (inset) was a JP, Chairman of the Burford Council from 1894-1897 and 1899-1922 and active in every aspect of town life. He is here on the steps of the Tolsey, attended by the Vicar and the local constabulary, reading with due ceremony the proclamation of the accession of George V in 1910. Both the town maces were on view, the Elizabethan Alderman's mace on the left and the large Georgian Sergeant's mace.

Left: the two maces in the Museum today, and the impression of the Town Seal of c. 1250.

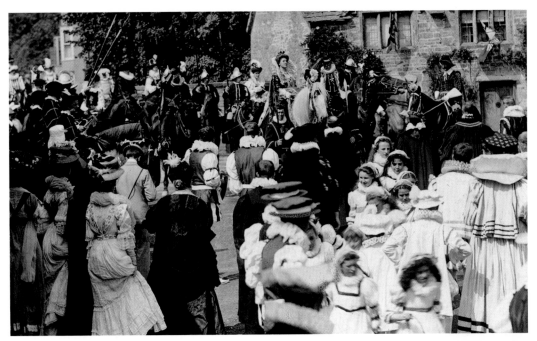

A Tudor Celebration

In 1574 Queen Elizabeth I came through Burford and was greeted on the bridge by the burgesses of the town with a loyal address and a purse of gold, an attention appreciated by her Majesty. In the early years of the twentieth century pageants were popular, and in 1908 the Queen rode again and was again greeted at the bridge and progressed up the High Street to Bury Barns. Photographs show at least two hundred Burfordians in Elizabethan costume crowding the streets. Although there were further pageants in later years, this was the high point of Burford's theatrical enthusiasm and has never been equalled since.

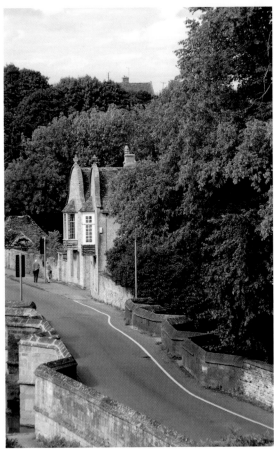

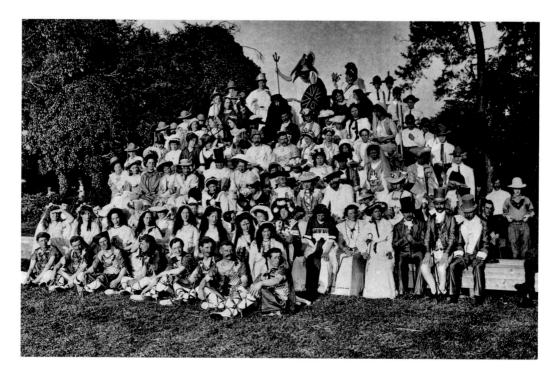

Rule, Britannia!

There was another pageant in 1909 though now the subject was less distinct. With Britannia at the summit of the pyramid the theme may have been Empire or, with cross-gartered Saxons and Regency bucks, it may have been a more general celebration of English history. Visiting Morris men now provide occasional colour.

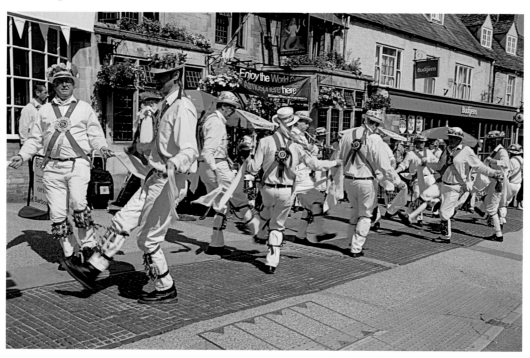

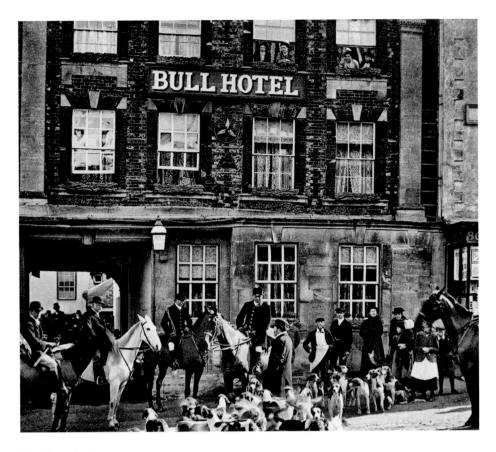

The Hunt in Town

The Heythrop Hunt meeting outside the Bull Hotel in 1914, where the maids leant out of the upstairs windows.

Below, a meet of the Heythrop outside the Tolsey in 1936.

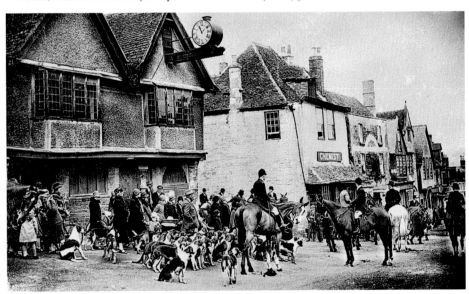

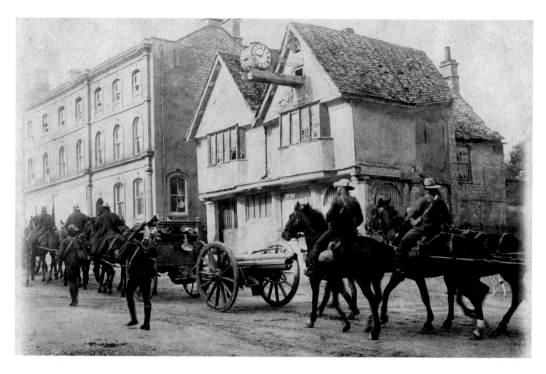

Guns on the Hill
There were extensive military manoeuvres in this area in the years before the First World War. Guns of a type that saw service in South Africa and the First World War but have now only ceremonial use are being hauled up Burford hill in 1903.

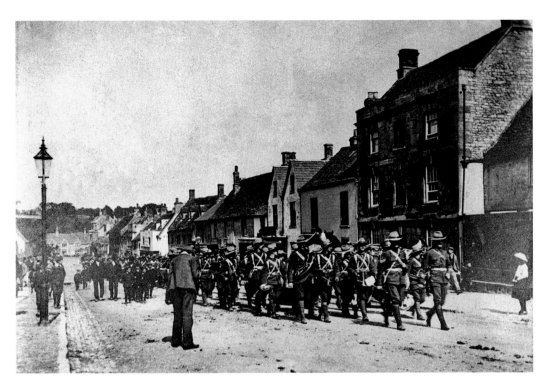

Manoeuvres on the High Street
A detachment of the Yeomanry marching through Burford probably also in 1903. On one occasion an entire kilted regiment of the Argylls on manoeuvres came through the town.

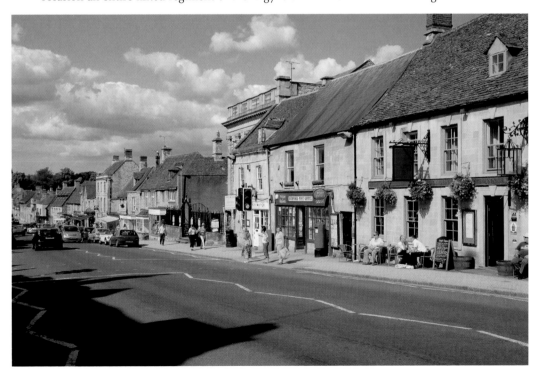

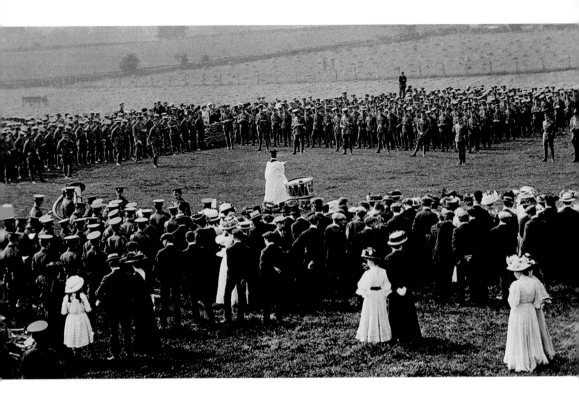

Sunday Morning

A drumhead service on Westhall Hill during manoeuvres. The civilian attendance suggests that the army presence created something of an occasion.

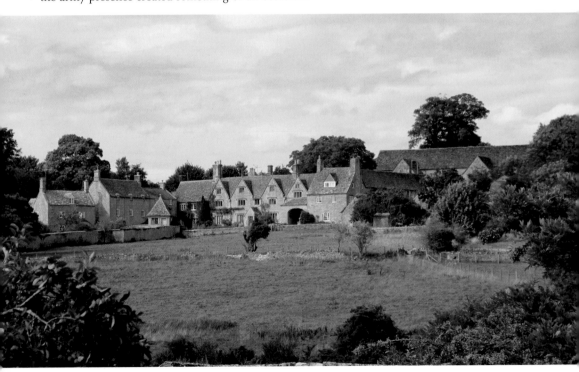

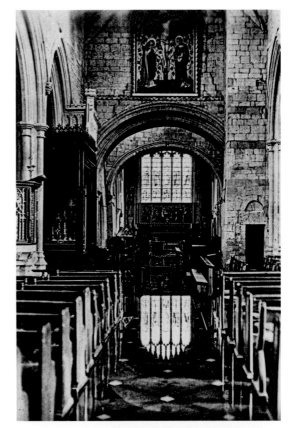

Water in the Church

The mill channel round the churchyard makes the church liable to flooding as here at the end of the winter in 1947 when melting snow and poor maintenance of water channels during the war led to problems.

Below: in July 2007 a downpour on the Cotswold Hills caused the river to rise abruptly and the church was flooded again.

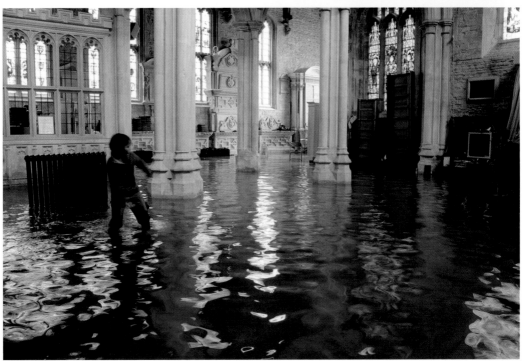

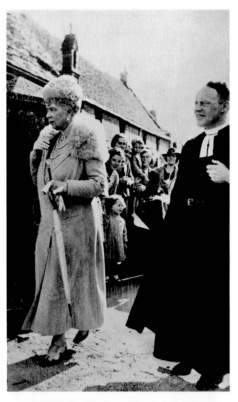

Royal Visits

Burford has had many royal visits, recorded and unrecorded, over the centuries, some in the course of medieval warfare. Elizabeth I, James I, and Charles I in the Civil War came here, and Charles II in pursuit of diversions. George III came through on his journeys and the Prince Regent kept his horses here. Queen Mary was here more than once in the 1930s often coming to Mr Warner's shop in pursuit of her passion for antiques. She is seen here with the vicar, the Revd R. F. Scott Tucker. During the war George VI visited the troops here and walked up the High Street. In the Millennium year Prince Charles came to unveil the carved Burford lion on the Falkland Hall.

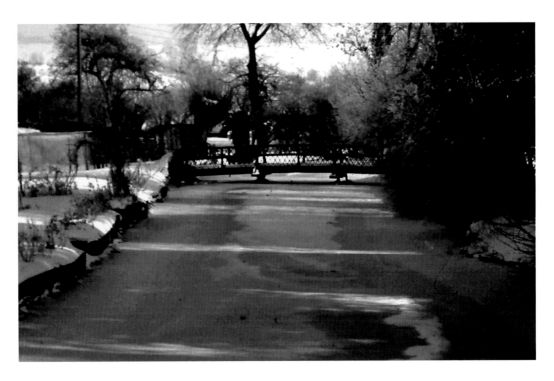

The Coldest of Years
The river and the mill channel froze over in January 1963, seen here just below the bridge. This was the year, the coldest for centuries, when the water main froze below the High Street and the piled up snow lasted until Easter.

Below the same view in warmer days.

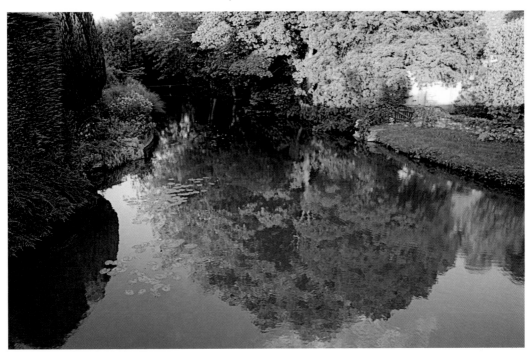

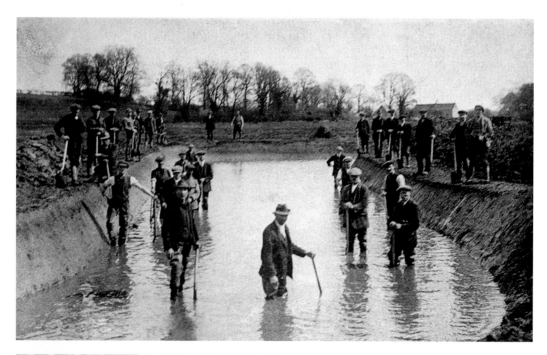

Making a New Cut
Below Witney Street serious
meanders had developed in the river
and a new channel was dug in 1924
to shorten the course. The parish
boundary still follows the old course
leaving parts of Fulbrook on the
south side of the river.

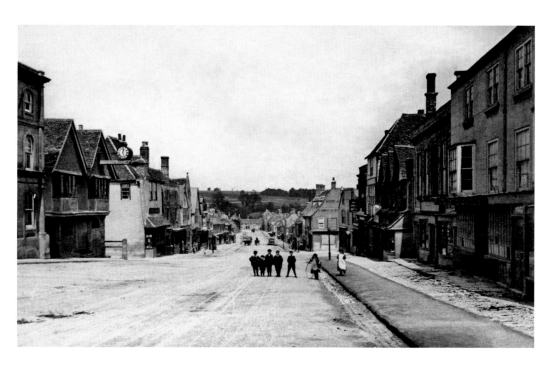

A Moment Caught in Time

Over a hundred years ago, four boys and a small brother, two girls, one with a hoop, and all determined to be in the picture when the camera was set up on the High Street. Perhaps around 1900 and unaware of the troubles to come, I wonder who of these boys would survive the trenches of the First World War?

Below, with more trees than ever before, the heart of Burford from the church tower.

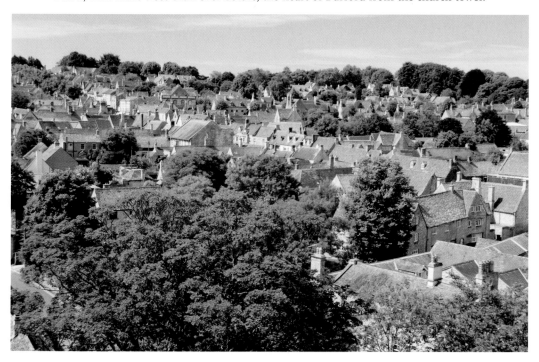

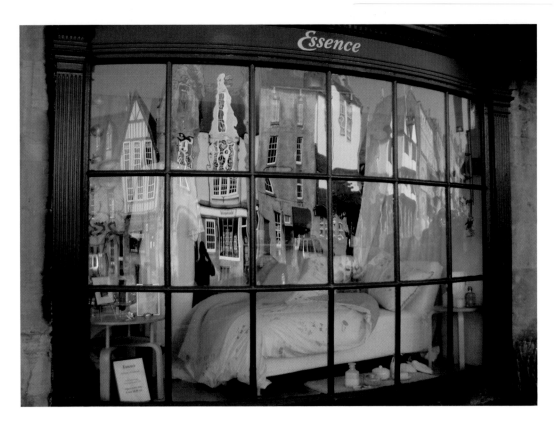

The Essence of Burford

From the George to the Tolsey – six centuries of the town's past reflected in its commercial present. And (below) Burford is always aware of the green fields that surround and embrace it.